DOs&DON'Ts

BOOK 2

DOs & DON'Ts Book 2

Layout by inkubator.ca
Edited by Thomas Morton

Written by him, Andy Capper, Johnny Ryan, the Fat Jew, Rob Delaney,
Jaimie Lee Curtis Taete, Alex Miller, Bille JD Porter, and Nicholas Gazin

VICE Media, Inc.
97 N 10th St., Suite 204, Brooklyn, NY 11211
www.vice.com

DISTRIBUTED BY:
powerHouse Books
37 Main Street
Brooklyn, NY 11201
phone 212 604 9074 fax 212 366 5247

FIRST EDITION 2012 / 10 9 8 7 6 5 4 3 2 1

Printed and bound in Singapore

ISBN: 978-1-57687-409-7

Special thanks to Matt Schoen, Alen Zukanovich, Travis Campbell,
John Martin, Andrew Creighton, Eddy Moretti, Milène Larsson,
Bruno Bayley, Amy Kellner, Ed Zipco, Taji Ameen, Liz Armstrong,
Rocco Castoro, Ellis Jones, Thalia Mavros, Lauren Dzura, Peisin Yang
Lazo, Sam Frank, all the photographers who gave us great pictures to
run uncredited (even now), all the readers who submitted photos high-
res and interesting enough to use, and everybody who decided to make
our jobs a lot easier by walking out of the house dressed like shit.

Even more special thanks to Suroosh Alvi and Shane Smith for starting
Vice and keeping this whole thing running and lucrative for two decades.
And extra-special-double-thanks to Jacob Hoye at MTV Books.

VICE

DOs & DON'Ts

BOOK 2 | OVER A THOUSAND MORE ZINGS, BURNS, AND RIFFS
FROM THE PAGES OF VICE MAGAZINE

THE DOS & DON'TS ARE BROUGHT TO YOU BY...

BRENDA STAUDENMAIER

Brenda takes pictures of naked girls for Burning Angel. She used to send us tons of photos from the darkest, scummiest, most semen-stained corners of New York nightlife until she moved to the sticks to raise her kids in a place that doesn't put fluoride in its water. (Too much can fuck up your teeth.) So not so much of the semen anymore.

NICHOLAS GAZIN

When Nick was 19, he interned at *Vice*, got put in the DOs for dressing like JD Samson of Le Tigre, and was promptly fired for excessive touching everyone in the office. These days he makes art for a bunch of bands we like, pals around with our childhood heroes like Raymond Pettibon and Gary Panter, and *still* touches everyone in the office, so I guess the joke's on us.

VITO FUN

The only photographer we've ever told to "tone it down" for the DOs & DON'Ts. Vito spends his weekends DJing parties for rich gays on Fire Island and his weekdays DJing for young gays on ketamine. He is also one of the few straight attendees at the gay S&M community's annual "Black Party," where he's taken photos that would turn your pubes white.

MAGGIE LEE

Maggie was raised by Japanese magicians in New Jersey and seems like one of those spritely little brownie girls who is constantly zipping around between everybody's legs and subsists entirely on cigarettes and coffee. But that's not true because we have personally seen her wolf down a huge plate of chicken fingers by herself and we're not going to lie, it made us pretty hard.

MIKE de LEON

We call Mike "Boots" because the first time he came to the *Vice* office he was wearing boots. It wasn't meant as an insult (they were nice boots), but we think he got wigged out by it and stopped wearing boots. Or at least around us. I guess it's pretty rude to spend the entirety of a guy's bio talking about a nickname he hates, but what are you going to do?

BEN RITTER

Ben Ritter is an ex-goth who plays in a Nirvana cover band, takes pictures of famous old people like Courtney Love for a living, and won't shut up about seeing Saves the Day at the West Orange American Legion hall before they got lame(r). When not being the 1990s, Ben shoots funny conceptual fashion spreads for *Vice* and less intentionally funny regular fashion stuff for regular magazines.

...AND MANY, MANY MORE, INCLUDING READERS LIKE YOU!

If wizened New England history professor isn't in the cards, this is what we're shooting for at age 80. Somewhere in between the mechanic that comes with a PlayMobil garage set and the last face you see on the highway before the chainsaw comes crashing through the windshield.

If you like a girl, you have to be willing to get the shit beaten out of you for anything she does. This rule sucks when you're dating a sadistic drunk who grabs jocks' asses then runs to the bathroom, but eventually you'll find one who only drags you into fights that are 100% unavoidable.

She's a bit Eurotrashy. But is there anybody alive looking at this that doesn't want to just sink their teeth into her perineum and wave her around in the air like a great white does to a baby seal on Discovery Channel Shark Week?

Here's to the black hoodie. Even tie-dyed space clowns from a freezing planet with an unbreathable atmosphere composed mainly of LSD can use it to pull their outfit together and make their style appear totally effortless.

God bless the party martyrs like Carl on the right up there. Taking him to the hospital to get his stomach pumped because he almost choked on his own vomit after chugging a pint of vodka may be a pain in the ass now, but it will one day become the stuff of friend folklore.

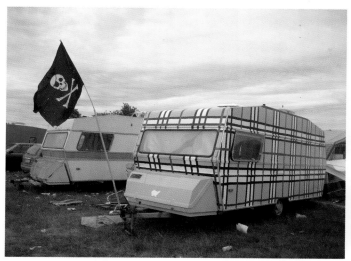

The best way to guarantee no one ever breaks into your trailer is to combine the two things that civilization has, throughout history, been most afraid of: pirates (hence the Jolly Roger) and working-class British people (hence the Burberry). Nobody would dare fly a plane into this thing, much less try to burglarize it while the owners are at the bar drinking pints of black sambuca and beating their children with spiked bats.

"And a-vun and a-two... *Vay down in Louisiana, down in New Orleans, vay back up in the...* Dance my arms faster, Rolf! In not so long ve vill have enuf money for a bag of Berlin's finest heroin."

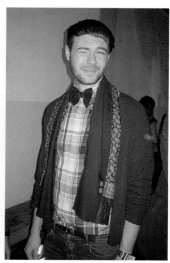

She's a streetwalkin' cheetah with a bag full of Boca Burgers, half-used jars of Manic Panic, and moldy dental dams.

Curious couple seeks like-minded individuals for discreet fun and games. Genuine photos a must. No time wasters!

How perturbed and uncomfortable does he look with his sad attempt at "weird guy"? Face it, buddy: You're normal. Strap on a white baseball cap and a J. Crew button-down and call it a day.

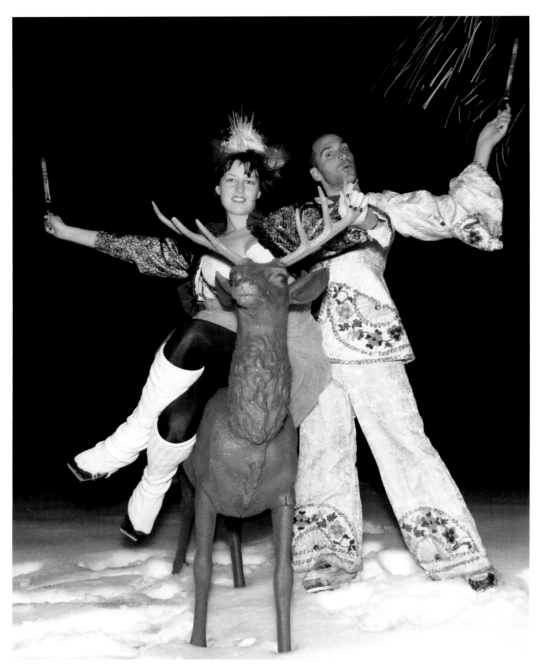

Whenever anyone talks about designer drugs these days it's all "k-holes" this and "depleted serotonin levels for the rest of your life" that, as if the part where they turn house parties into a weekend-long Siberian sex rite didn't count for shit.

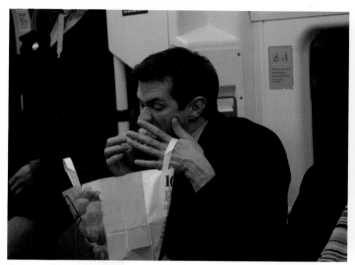

Yeah, cram it in your maw with those trembling fucking fingers. Show her who's the boss around here. Show that chicken and mushroom tartlet how you're sick of taking the train to work at 8 AM every day for 25 grand a year just to wait on tourists browsing expensive shoes.

Dance like nobody's watching. Love like you've never been hurt. Sing like nobody's listening. Fall asleep in a children's playground with a fully loaded handgun on your belt.

The ubiquity of skulls on clothing has created a funnel effect, and at the bottom of that funnel are the Australian raver dads you see in the Berlin airport wearing distressed skull silkscreens on their pink golf shirts. That's who is supposed to be wearing skulls today. Not this girl.

See? You turn around and there's another one, distracting us with more stupid, gay skulls. What are they supposed to be? Scary?

Sure, old rockers never die, but it's also true that the only pussy they get is from deluded middle-aged Dutch crusties with hair that smells like wet dog and clammy ass cheeks hanging out of labia-strangling leather shorts like doughballs with not enough yeast in them.

When you're in your early teens, your getting-laid quotient is already low enough for you to dress like a cartoon delinquent without fucking things up for yourself. Take advantage of it while you can, because as soon as you hit 20 it's either one or the other.

Or I guess you could move to Australia and open a death-rock accounting firm named after a Birthday Party song with your ex-skinhead green-card wife. Sure, why not?

Maybe a smidgen too much emotional honesty for the first date, but the sooner we get our foibles out into the open, the more we can love each other unconditionally forever and ever.

What sucks about people who claim they "don't give a fuck" is how often they're loaded down with a shipping crate's worth of hideous accessories and hair product. If they really looked like they didn't care, it wouldn't even be an argument in the first place.

Getting metalheads into the sack isn't exactly string theory. Still how genius is it to base your look around the fact that they all want to fuck Ozzy but are too fucking gay to admit it?

What the hell is this, Christmas in Micronesia? Come on. Your culture has been dealing with winter for 26 centuries. I think you can come up with something a little more professional than draping yourself in the sofa blanket and bathroom rug like they're animal pelts. You look like a fucking Ikea Viking.

On the other hand, if you're a Micronesian Chewbacca who's never seen snow, you might want to consider something a little more layered and you-sized than this unless you're studying to be a laugh therapist.

If you ever get into an argument with some guy who thinks people's lives are 100% genetics, ask them this: If Henry Rollins was born somewhere weird like Malaysia, would he still grow up to be the same guy or would his environment make him corny as shit? If they're still insistent, show them this picture.

Wow dude. Thanks for squeezing in our party between loading the dryer and your 3 o'clock jack sesh. Oh, sorry, you're texting. Don't let me distract you.

I don't know which charity operates on donations of vomit, but I am definitely ready to give till it hurts. Slide that Tupperware over here.

Damp country lanes were designed by the gods as places for you to take pretty girls with better taste than you in books. If you're lucky, she'll let you dry-hump her on the grass for a while until a couple of joggers get too close and she gets sketched out.

Peaking on acid at the same time the opium suppositories kick in is one thing, but piloting an octo-cycle at a trillion megapixels per second through the backstreets of Barcelona at the *same* same time? Thank God he's wearing adequate headgear or he'd end up seriously damaged.

Rampant corruption and crushing poverty are probably the worst vestiges of communism in Eastern Europe. Guys like this one right here are the best.

What if she is a reclusive art nun who dedicated her life to writing about 18th-century neoclassicism and she's never been touched by another man before but for some reason you're the one she chooses? What if that happened?

The sooner children accept that life is hell and we've all got to get through it alone, the better. If that means dragging the kid out in a blizzard and leaving it to fend for itself, so be it. One day the little whelp will show up on your doorstep and thank you.

Uh oh. It's time for the imaginary friends to go to bed or they'll be too sleepy to put ketchup in Dad's coffee tomorrow morning.

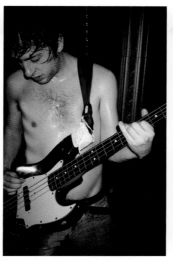

Does playing bass really make anyone sweat that much? Put your shirt back on, Frenchy. You aren't a bricklayer.

She looks like an undiscovered species of lemur.

Some eager beavers are just cursed with faces that look perpetually horny. Sorry, man, but you scare women when you point that thing at them.

The worst thing about this half-assed Pete Doherty impersonator isn't his shitty little hat or the tattered plimsolls or the deadly halitosis. Nope. It's the fact that we can't somehow jump into the photograph to pound the shit out of him. Thanks a lot, reality.

It took Danny Motherfucker and Rikki Shitsville 20 pictures and five minutes of silently primping and pouting to get this pose just right. All you could hear was their leather jackets creaking and them starting to pant from the exertion and their little feet tapping around on the sidewalk.

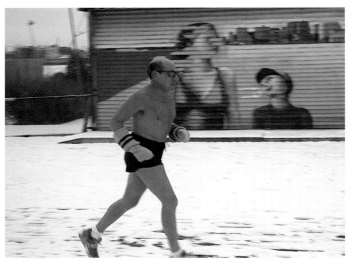

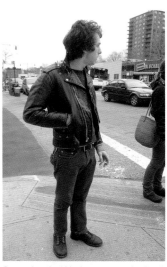

Your testicles have to get some fresh air once in a while. In fact, letting them run around the block in the snow is actually beneficial for sperm production. Don't forget to put a pair of sunglasses on them though. Balls have very sensitive eyes.

Remember the kid who was a grade ahead of you in junior high who listened to MDC, knew *Watchmen* by heart, and smoked pot out of an apple? He hasn't changed, and he's still putting the rest of us to shame by not giving one flying ounce of a fuck.

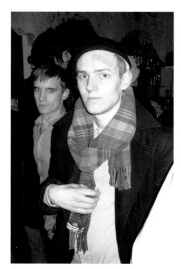

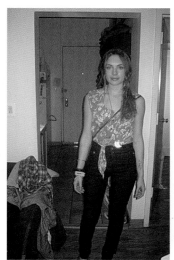

An *On the Waterfront* vibe is always a strong look, but a bandage from somebody trying to break a beer bottle on your head the night before makes it titanium-plated.

Oh dear Lord. Look how soft and unspoiled she is. Too bad you're on your way to a party where the girl you drunkenly cheated on her with last week is definitely going to be. Why do girlfriends only ever look this good when you're engulfed in a flaming pillar of regret?

These European art-crowd guys have to be carefully timed. You don't want to be there at dawn when they have golf-ball eyes and are telling you what they think of Cerith Wyn Evans. But if you can catch them at beer number three and bump number one there's definitely going to be some high jinks worth hanging around for.

If I'd spent $10 billion on a jacket and $6 squillion on my face I'd expect to not look like Kaa from *The Jungle Book* in a tranny wig.

There isn't much more of a DO than looking like a freshly reincarnated David Wojnarowicz (but this time around without the AIDS).

These sardonic 5s may not look like much but trust us, they are the most important people at this bar. They are as funny as old fags, they know where to go when it gets boring here, and they are guaranteed to have a couple of better-looking (but dumber) friends.

First she packed herself into that skintight little number and now she's filling bowls with cigarettes to spread around the party? This is our version of what's waiting for you in heaven after you suicide-bomb a city bus.

Bonsoir, Chef European Beefcake. What's on the menu tonight? Your succulent cock artfully placed on a pile of the creamiest foie gras?

Oh, to be wheeled to the banks of the river Styx by an immaculately attired angel of death who smells like lilies and brimstone and softly murmurs songs of praise in a stately baritone.

This got sent to us in the spirit of "Look at this stupid white trash" but, um, fuck you. What on earth is wrong with a mom and dad who are so goofy that they wear matching baggy-jeans-and-ass-crack t-shirts to the Strawberry Festival? This is our family.

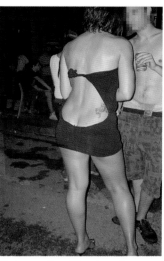

"Coming through, people, coming through! Clear the way or I'll be late for the Stupid Assholes with Pink Jackets and Tiny Backpacks convention. I'm due to give the keynote address in less than 30 minutes! What's that? Well, since you must know, the topic is 'Being a Ball-Sucking Shitstain with Fucking Shitty Poodle Hair in 2012.'"

You know you're a filthy whore when even your ass is frantically trying to claw its way out of your dress just to get the fuck away from you.

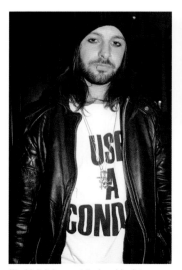

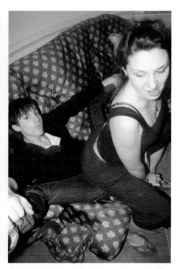

Wouldn't it be great to drag him into a time machine back to where his dad is about to fuck his mom and then the dad looks up and sees his shirt and goes, "Oh yeah, a condom," and then you watch this smug twat disappear as his dad slips the rubber on?

Why couldn't Dylan Carlson have lent the shotgun to this fey little grunge elf instead? Sure, his sister and mom would cry at the funeral but at least nobody would be stealing their Super Shiny Straightening Serum anymore.

For the last time, freaking only works if one of you is at least pretending to have a dick.

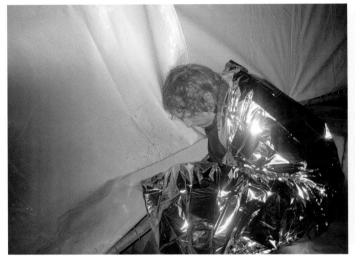

That space blanket is perfect. I want one the next morning that I'm promising God that I'll never do it again as long as I don't die this time.

If 20 drinks is what it takes for you to have the courage to finally get a procto-logical exam, so be it. Just get it done already. Asshole cancer is no joke!

Look at him, taking back "wee ginger cunt" the way rappers took back the n-word and womyn took back the night.

Most supermodels are stupid, boring Aryan cunts. But what about when they look like Miles Davis reincarnated in the body of the new female Antichrist whose mission is to destroy all DON'Ts? We're fastidiously matching our socks to our shirts so maybe she'll stop staring at us like that.

You thought she'd left but she's only ditched her friends and come back upstairs and now you are definitely going to fuck her tonight. This is how people marooned in shark-infested waters feel when they see the helicopters coming to save them.

"Hello? Auntie Apple Turnover? I think me and Quackers took a wrong turn somewhere near Gumdrop Cove. Can you tell us how to get back through the Peppermint Portal? It's scary here."

How come every after-hours drug party at some random loft these days is filled with predatory old queens who offer you bumps of Rohypnol and claim it's coke? Aren't these guys supposed to be dead?

If you've ever wondered what that shadowy figure at the foot of your bed you see when you've just woken up from a nightmare looks like in direct light, here you go. Enjoy trying to get to sleep ever again.

"I love what you did with your hair! It's so cuntrag-y."

Wouldn't it be great to take a time machine back to 1982 and start a "Normals Night," where everyone would wear bunchy polo shirts and cargo shorts and one of those baseball caps with the fishing hook on the brim and dance to late-90s R&B?

The best part about watching places like Cyprus and Romania find out about punk is that phase right before they figure out the uniform and everybody has to make do with whatever they can snag from their grandparents' closet.

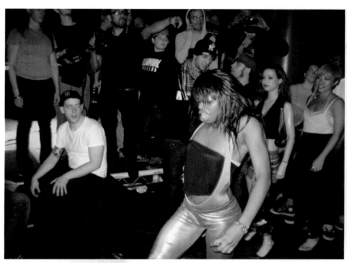

I don't know what all the fuss is about mermaids. They're actually fucking hideous.

And the winner of this year's San Francisco Dry-Heave Invitational is: girl who laced ribbon through the surface piercings on her back and tied it together like a corset then let the whole thing sit until the holes were runny and swollen.

We try to avoid photos that have such shitty res, but we're making an exception for this snap of one guy eating out another guy's asshole, captured at 10 AM on a weekday by a reader in Australia. We're not even going to try to make a cute comment here. Just look at it. Behold it.

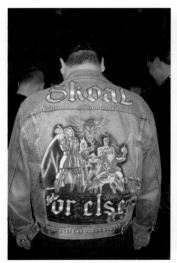

Or else what? Monsters will fight us? We're not your five-year-old brother, guy.

Would it be unfair to say this girl looks like a retard based on a face she made for about 1/16th of a second? I bet that's how real retards feel about their one retarded gene.

"Oh, you haven't met Gerry's new girlfriend Marie yet? Classy broad. I think she's going to be out tonight."

For some reason I always thought that taking him out of the water and putting him in a pair of sweats outside the drug store would divest King Neptune of some of his majesty and grandeur. I was wrong.

She shows up at the bar wearing a Mexican blanket thing and carrying a Borges book, wagging her finger in your face for still being out at 4 AM on a Tuesday. And what do you do? Follow her home like a puppy while your friends belittle you. Because look at her.

Life is beautiful for people who refuse to be jaded by it. Even in the bleakest, most miserable of all situations there's always little glints of hope and joy peeking through the awfulness. Never stop looking for them.

Guy, relax and button your shirt back up. As long as this girl has even a sliver of taste you're in, but right now she's just asking for a light.

Forget about protests and signing petitions and marching on Washington. If you really want to take a stand against this fucked up capitalist society we're forced to endure every day of our lives, you need to throw a wrench in the works from inside the system.

It's weird how often "tough guy" these days is just a hat away from "beddy-byes."

Doesn't this picture remind you of all those times when you are at the perfect balance of drunk and highness, then someone hands you one more beer and the night falls into a puking shambles. Who is that asshole?

Real nice. Your parents spend years fighting against ugly racial stereotypes and then you go and be this.

When the only way you can deal with the subway is to squeeze your head so far into the sleeve of your coat it looks like you got hit with a disintegration ray, it's time to accept the fact that maybe you're not cut out for the city.

Oh cool, it's The Fear in sweating, jiggly, hairy human form. Have fun screaming and begging for mercy as he chases you down the corridors of every bad acid trip you've ever had.

Those $4-an-hour summer jobs you had as a kid were so boring you'd find yourself checking out any kind of ass just so long as it momentarily distracted you from cleaning the boss's fucking car for the third time that week.

This girl is pretty hot.

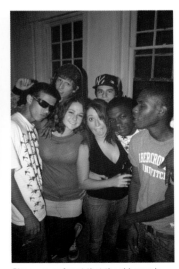

Fuck shelling out 20 bucks to some stall on St. Mark's for an iron-on print that melts the first time you wash it. Taking the shoe polish to an old Hanes is what really says, "I'm in with this band for the next three months."

Pretending to laugh while your eyes well up with tears is the worst way to deal with the fact that you fell asleep first at the slumber party. If you want to really show up those cunts, just be like "What?" and leave it on your face—for days if you have to.

Please never forget that the old gang is always back at home wondering where you've been all this time. It's like at the end of *Labyrinth* where the puppets say (in their little puppet voices), "But should you need us…" And, now I'm crying.

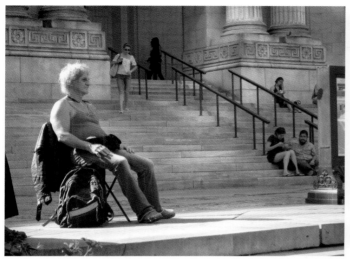

And on the steps of the Met, LES Sally continues her 20-year vigil for the return of the old New York.

If your posture is roughly that of a pigeontoed ballerina who needs to pee, something loose and concealing like a linen summer suit or one of those old Cuban man shirts might be a better option than Hammerpants and a two-year-old's backpack.

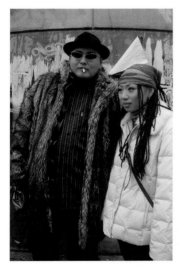

Japanese people are really good at taking something fairly complicated and streamlining it down to perfection, which is awesome when they set their minds to computers or cars, but less so when they set them to shitty rap.

Always check the footwear before approaching a crazy. Knowing the difference between two different colored Chucks and a pair of filth-encrusted boxing boots is the kind of thing that may one day save you from a 20-minute lecture on the color of horses' souls.

I know you kids think it's all one hilarious joke, but whoever dug up Celia Cruz is going to be in some seriously deep shit when we get done with the reinterment.

If you're a girl who looks like a faggy boy, don't fight it. Just throw on an ice skating outfit, hit the local cruise bars, and try to win back a few for our team.

Native Americans may have garnered a lot of cred by making something out of every part of the buffalo, but they will forever pale in comparison to the natives of Quebec until they learn to make something delicious out of every part of the everything.

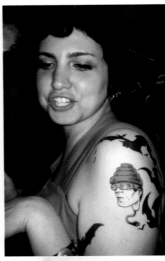

The flock of vampire bats is a bit much, but getting Mark Mothersbaugh's unplugged head on your arm is a good way of saying "I'm down with the nerds" without being a big nerd about it.

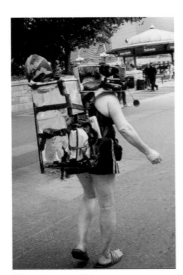

Why would you wait for some company to create a satellite-feed surveillance pack when you know they're going to slap their logo all over it and make the cooling system a piece of shit. Just build the damn thing yourself and get to recording every single second of every single day ever.

If you've ever nailed down a look that is 100% unassailable, there's a moment where the smiling stops and for a second everything recedes into the background as the enormity of it all washes over you like a thousand yawns happening at the same time.

There are certain places like teepees, the tops of barrels, and those inflatable icebergs that are so perfect for doing bong rips they actually increase the strength of the weed. We call them "toking stations" and if you hit three in the same night, it will make you so stoned you can read lips.

Oh good, it looks like the direct ferry service from the Island of Dr. Moreau to central Paris is up and running again. That's a relief.

God, when redheads get drunk they become such bubbling, horny cauldrons of temptation it makes you start to think that maybe all that devil's-spawn stuff is actually true.

Somebody sent us this under the heading "See, you're wrong about flip-flops." We'll concede the flops on this one, but that's only because dude is so broken in he looks like a human jean jacket.

Right now the big thing for girls in Brooklyn is this Florence Grungingale look where you stay up for three days and help people figure out whether or not they're color-blind.

We know it's rude to eavesdrop, but he had a direct line to the floor of the Wacky Fellers Futures Market and we really wanted to know how things are looking for goofballs in the next quarter. Evidently pretty good.

Eastern Europeans in America can be a rough lot. But when they forego the roving packs of drunken rapists in Greenpoint and tap into their inherent Balki-ness, it's so endearing it makes you wonder what all that Cold War shit was even about in the first place.

Fuck X-ray specs—when are they going to make a pair of glasses that turn all the rubbery, fake-titted trophy wives of today into their classy 80s equivalent?

One question that all those Terri Schiavo types never had an answer for is how painful would it be if you woke up from your coma five years down the road and everything you once loved and believed in is now dead and gone?

You'd think after the first few tries she'd figure out to take off the heels first.

First off, a burrito that size would be disgusting. What is that, like 30 pounds of ground beef? Even if you were ever that hungry, the only decent bites would be the ones in the very middle. The rest of the time you're just repeatedly smashing your face into piles of lettuce and sour cream.

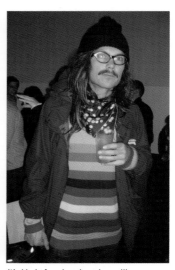

Putting flip-flops at the bottom of a 35-year-old Muppet raver is like tossing a counterfeit five on the body of the hooker you just killed.

It just goes to prove the old saying: You can lead a Winnipeggian to art, but you can't make her stop looking like a ridiculous Incan pipe-cleaner lady in mom jeans.

It's kind of cool seeing places like Venezuela and Hungary get their own *Ugly Betty* franchise but someone really needs to step up the QC.

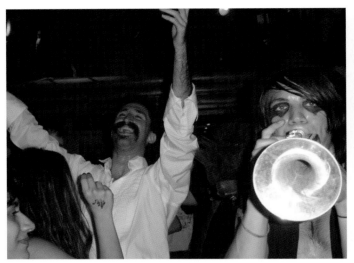

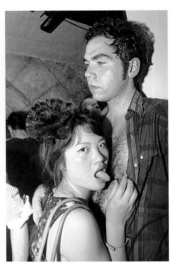

All the death and darkness in Mexican culture can be a downer for day-to-day life, but when they cut loose it ends up looking like Satan's bachelor party.

Why can't they make porn that makes me feel as horny as this does?

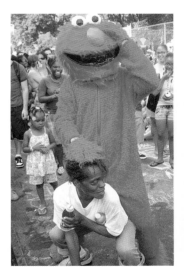

"Yessss! I'm totally being fucked by a famous guy! Hope nobody can see us."

Fuck what the kid thinks. If you got some trim last night, let that flag fly.

They might make you look like a shameless-ly lazy fat pig, but these things are great for catching up with the ice-cream truck.

Tits at the pride parade are a dicey proposition because you want to soak them up with your eyes but you also can't be sure if they were just stitched on by a surgeon last week, a couple hours after she had her dick chopped off.

Nobody's saying you've got to walk around with Haeckel's Theory of Recapitulation in Latin on your back, but when even four-year-old girls are baffled by the Grand Canyonesque gaps of logic on your shirt maybe you should go back to sports.

I wonder how tough guy here would feel if he knew how many gay dudes are going to jerk off to this photo.

Face it guy, Barbara is GONE. No matter how long you wear the hair she left in the plughole stitched into the back of your head, it's never gonna bring her back.

Bikers could once make people piss their pants in fear. Now it's only through laughter because they look like a midget Anjelica Huston in drag.

When you've finally dicked over the last of your friends and hit rock bottom, you can either skip town and try to get clean, or you can dress up like a children's book character named Fresh Starts and barter your way back into their good books with hugs.

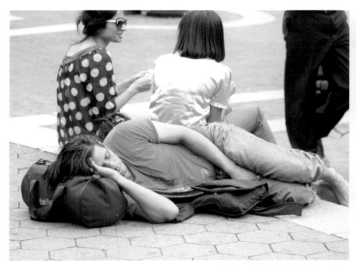

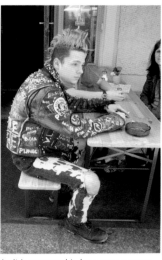

You're so fucking sleepy that not only do you have to nap in the park like a baby, but you also have to take your shoes off so your tootsies can air out? What were you raised by? Sloths?

Isn't he supposed to have open sores on his face and a mongrel dog that's dying of starvation whimpering into a half-empty bowl of beer? He's like if Urban Outfitters did a line called "Distressed Rancid."

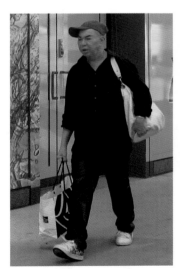

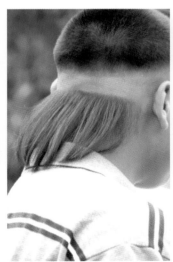

I know the sales guy said that cancer hats, grandma purses, and leather pants were really big with the kids these days, but dude, I think you got burned.

Forget biofuels, scientists need to look into harnessing the power of dumb. You could probably run a midsize city on this guy's napestache alone.

All those people whining about how the new *Indiana Jones* or *Ninja Turtles* is "raping their childhood" have no idea what that actually feels like.

What a sturdy set of wheels. I bet if you crashed that into the back of a mystery white Fiat in a Parisian underpass all the occupants would totally survive.

Today the people who invent stuff look like Craig and Johnny or whatever their names are from YouTube, but in the 1800s inventors strolled about looking like this, chucking orphans into the River Thames for fun.

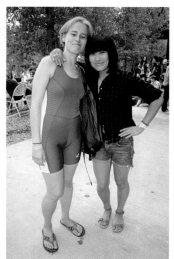

You could give a frog a Chelsea cut and I'd kiss it, but put one on her and I'm already saving up to pay for our children's private education.

So is camel-toe pride her whole deal? If so, we're getting in line for a photo with her too.

If you'd have said, "Imagine a nu-rave Pakistani nerd who looks like he's pissed himself at an art gallery," I never would have dreamed it'd be somebody I'd want to go for a beer with.

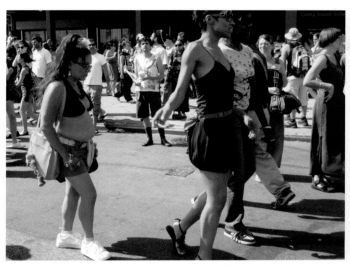

I don't care if you've got some drawn-out postcolonial justification for it or you just like making her match, keeping a pygmy servant in this day and age is a tad extravagant.

It can be pretty hard to walk into a party if you've had a big fight with one of your friends or you know your ex is going to be there, but imagine how bad it must feel if you're just a person who really sucks.

The real tragedy of AIDS is that instead of thinning out the weaker portions of the fag herd, it hit all the partiers and left us swimming in Renn Fest nerds whose idea of here and queer is warming up for the Castro St. hip-hop twirl-off on the way through the park.

I doubt anyone's going to waste their time asking someone into sports to "act their age," but for the sake of decency could you shoot for something a little higher than five?

Oh I'm sorry, m'lord. Do I *bore* you? I'm sure you feel nice and secure in your pampered little world, but mark my words, baby. One day the world is going to rise up against your lazy bourgeois asses and you will be the first against the wall.

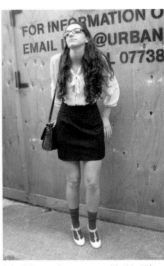

While the nation's youth are bitching about how there's nothing to do tonight and the nation's Boomers are bitching about how they're not young enough to do anything tonight, once more the greatest generation is soldiering on without complaint, turning every night out into a David Lynch movie.

I don't know who came up with this "lifting my ass up off an invisible ledge" pose girls are doing all of a sudden, but I would like to personally thank him for turning the world into a mental jacuzzi party.

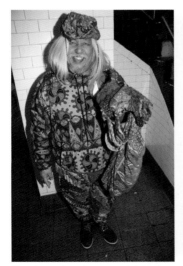

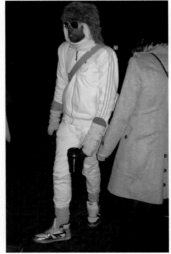

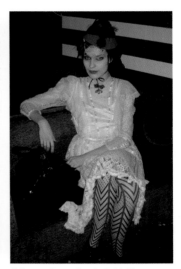

Next time you've taken so much ketamine that the carpet pattern keeps permutating and growing into a giant gnome body with a grinning Chinese genie face, don't freak out—jump on him. That fucker's got wishes out the yazoo.

We were bitching about how winter turns everyone into dumpy black nylon hunchbacks when this arctic commando sauntered up and said "I heard somebody was feeling gloomy, so I brought over a drum of cocoa in my Polar Assault Tank®. Who's ready to roll?"

Not sure when goths started letting full-blown 10s back in their ranks, but this bodes extremely well for the crotch tailors industry.

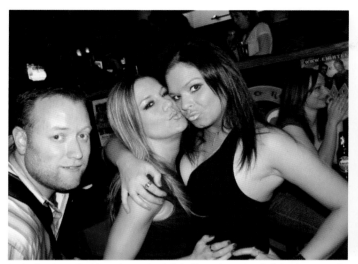

Dude, if you're really dying to know what it feels like at the center of all that bronzer and cheekbone, I've got a freshly used waffle iron you're more than welcome to stop by and press your face into.

So letting kids use their little fingers to make us cheap, cozy sneakers is out of the question, but it's perfectly fine for them to use those same fingers to spin themselves around on the filthy sidewalk eight or nine times a day to make their older brother some beer money. That makes sense.

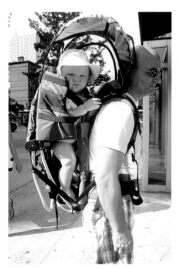

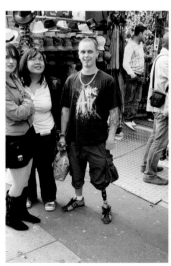

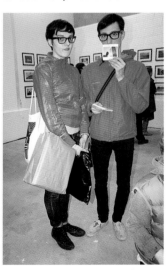

It's great you're making sure your baby is comfy and not getting sunburned, but when it's reached the point that you've built the kid his own howdah you are basically the Blaster to his Master.

Losing your leg at a Prodigy concert must be fucking harsh.

Wouldn't it be easier to just jerk off onto a mirror than to spend your life making pained conversation about art with your dykey doppelgänger?

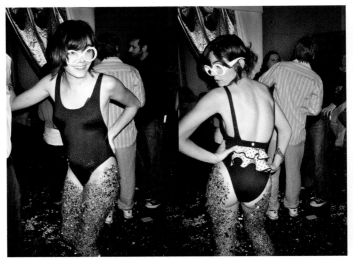

Reinventing the way people think about pants may earn you a name in the fashion industry, but reinventing the way people think about chaps, theater floors, and not realizing you still have a bunch of jizz on your legs is the stuff they make saints out of.

While most whites are content to lay back and shit out the occasional Winston Churchill, couples in India are getting together and coming up with flavors of baby we didn't even think were physiologically possible.

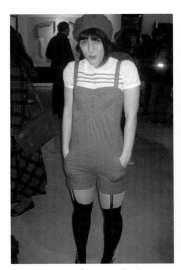

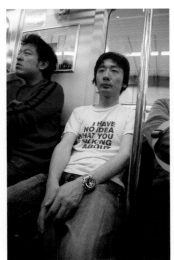

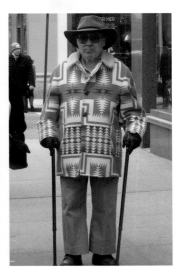

Could you cross a few more wires in my brain? Making me want to bury my nose to the hilt in Madeline's asshole wasn't bad enough, so you turned a Strawberry Shortcake jumper into cabaretwear? Why not tattoo a copy of my grandma's face across your tits while you're at it?

Are you kidding me? With that face? With that shirt? With that fucking face?! The waiting list to be this guy's friend must make the National Kidney Fund's look like a gum wrapper.

I know we say this any time there's a non-threatening old man in the DOs, how he's our model for aging gracefully, but this vaguely native Hummel-man who's really into symmetry is it. If we don't get to be him for at least an hour before we die, we are going to wreck the shit out of heaven.

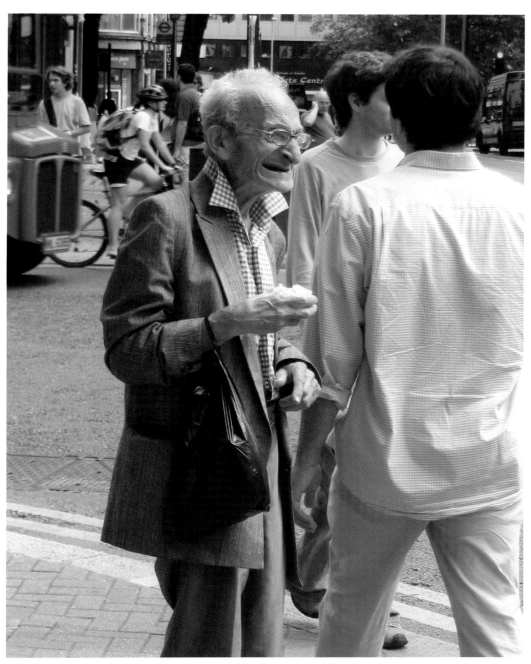

Oh, who are we kidding? We'll just be happy not to end up as a medieval depiction of plague.

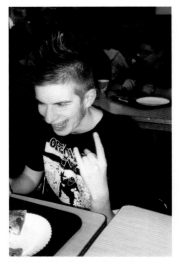

High school isn't always the raging bonanza of drugs and casual sex and partying that Hollywood wants you to believe it is, but in terms of lunch, they got that shit locked down.

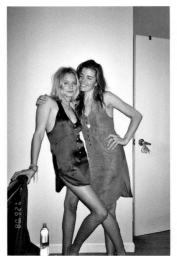

Can you imagine how boring this would be if you were a billionaire who had threesomes with a different set of girls for each day of the week? You'd just be looking up from your desk like, "Oh, right, it's Tuesday. Well… I guess we should get started then…"

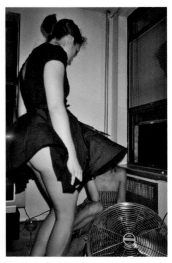

This is your reminder now that summer's almost over to kick each remaining weekend into overdrive so everyone will have plenty of these to tape to the back of their eyelids come winter.

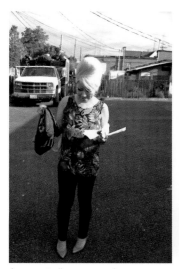

Japanese trailer mom sounds way more like a half-assed Mad Lib than my new favorite beat-off fantasy.

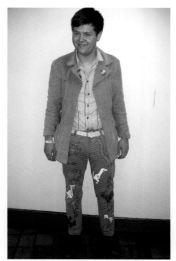

I never understood that thing where older dudes wanted to "corrupt" their friend's younger brother until I saw this guy. I don't even have to take part, I just want to sit there and watch him get *wrecked*.

Mon dieu! Is that a halo glinting off the head of this *petit ange* or did NAMBLA finally perfect their conversion ray?

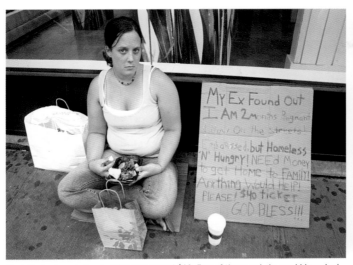

That Starbucks salad and coffee cost around $10. Four of those and she would have had her "ticket." Fifty of them and she could afford the abortion.

"Dear blog about my awful life,
We had a party to celebrate the six-week anniversary of Mary's erotica website and it ruled. Steve and Billy baked these hilarious cock cupcakes and they were a huge hit, especially with all the decaying old prunes who made up 89% of the guests."

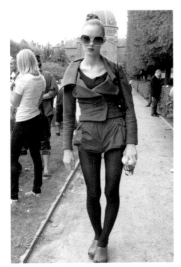

I guess fashion is vital and art and stuff, but it also allows for "shoots" that are all about 30 people helping one person take photos of a 16-year-old anorexic giraffe from Estonia.

Ah, the independent spirit of the true Parisian who wears diapers underneath leggings, starts drinking Pastis at 8 AM, and never plans on making his 1950s bathroom bigger than a matchbox despite the fact that his wife and three kids all live with him despite the fact that the youngest one is 28.

"Look, I ain't gonna make it into work today. My dick exploded."

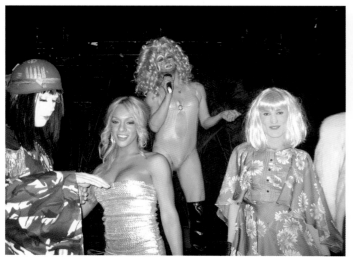

Not trying to sound queer or nothing, but how are regular girls supposed to compete with this? They should be thanking God every day for remembering to put vaginas in their crotches.

Pastel-wearing best-friend's-younger-sister girls without a single sharp corner are so anathema to all the dingy, wasted shit you got up to last night they should sell them next to the register for hangovers.

Oh, so you had a big weekend because you drank at a couple bars and maybe went to a show? The schemes Eddie Rockets and Tolan are getting up to every day in East Tampa make your big-city life look like a crippled, 90-year-old shut-in's.

How much of a better trip would it be if you bought your drugs off this guy rather than some fat college kid who doesn't even bother looking up from his Xbox?

You know that moment when you're trying to break up with a girl and you keep backing down and being like "Sure, OK," but then you just go "Look, Amanda, it's done. Deal." And it hits you that you're finally free? That must be what heaven feels like, but times forever.

You might want to consider sparing the rest of the gene pool your contribution if you're too lazy to be a cop but too much of an asshole to just be a mailman.

Someone needs to tell gym shorts that "Whatever blows your hair back" is more of a general suggestion not to stress about what you're into than a call to spend 45 minutes straddling a subway vent on ecstasy.

If you ever want to hear the sound of time marching slowly to the grave, just unplug the jukebox at any bar on Third Avenue.

Can you imagine how hard it is to be a bully these days? You basically need a doctorate in Advanced Nerd Studies just to know which one to wedgie.

Flesh-colored tights are bad to begin with, but when you subtract the skirt from the equation and add in about 30 hours of straight partying it makes it look like you've smeared your whole body in anti-boner cream.

If I were jailed for 25 years after a failed armed robbery, I'd want this guy to have been my sidekick and this to have been his facial expression at the moment I came up with the idea to confuse the bank teller by disguising ourselves as ghosts.

I don't know who told you that laying yourself out like the chicken in a picnic spread is a good way to meet guys, but unless you're into starving cartoon shipwreck survivors, they were fucking with you.

PS.

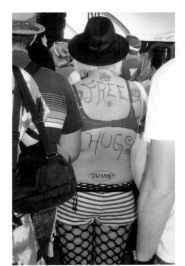

"Free Hugs" is rapidly becoming the most surefire indicator of molestation since the facial tattoo. It's painful when it's on a button or shirt, but looking at that part of the R that's smudged away from a parade of strangers' fingers is like being taken to the cave where childhood goes to die.

If you've ever wondered how blind people watch horror movies, the way it works is they find a person whose face is the same kind of scary, then feel it until they freak out. These girls right here are the visual-impairment editions of *Ring II* and John Carpenter's *The Thing*.

Blossom may seem lame to you or me, but for Hasidic teenage brides that bitch is basically the Fonz.

There's whining about how you hate what Europeans did to American Indians in the safety of your history class, and then there's getting out there in the field and actually giving the poor bastards a snuggle. How far are you willing to go?

A cross between Jennifer Herrema and Lindsay from *Freaks and Geeks* AND she's half-Asian or something? I don't know if I want to fuck her or pack her in a bong and smoke her.

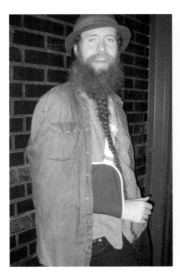

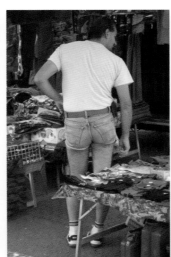

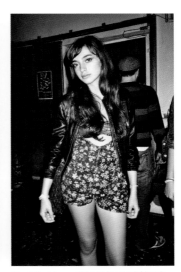

A two-foot-long braided beard and a broken arm. Imagine the stories this guy could tell if he was ever coherent enough to tell them.

While you and Cousin Geoff couldn't lay your hands on any illegal hunting knives today, you can at least still watch his *Faces of Death* box set once you get back to the basement he lives in.

As cool as it would be to have telekinesis, you know there'd be no way to keep your brain under control when a girl like this walks up with her top held together by one stressed-out button.

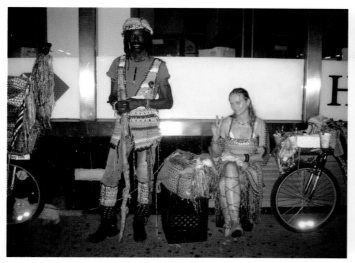

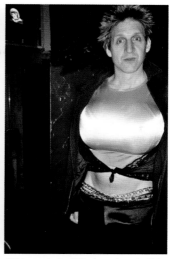

One way to tell you're whipped is when you let her pick out your mental illness.

Chicks are lucky. If they've got a set of big juicy melons they can be forgiven for a multitude of sins. Dudes can't compete with that.

Our new favorite road-trip game is Illiterate or Secretly Hilarious. You can play it at any rest stop in America and if at least one of you is stoned, the debates will last for hours.

You've got to be a real dickhead to pick a fight at a crafts fair.

I'm not a big fan of corporal punishment, but whoever introduced nu-rave to short-tempered meatheads and aging student-body presidents deserves at least a flogging for turning Saturday night into an endless parade of bloated DayGlo Muppet Babies.

Few moments can solidify a friendship quite like finding your dad's butt plug in the dresser the weekend he's out of town. We hereby pronounce you Pals For Life.

Dog lovers and old fruits in the park can each be a Sunday bummer, but they have the opposite effect when welded together under a voice that sounds like Harvey Fierstein farting through a French horn.

Theme couples were a DON'Ts no-brainer until they started ratcheting up the esoterica and picking things like "Picture of someone's drunk Russian parents from the 60s."

You know what? Fuck a summer. It's always a million degrees hotter than is worth doing anything and nine out of ten weekends you just end up surrounded by kids in t-shirts at yet another barbecue. Fall is the partier's summer.

College brochures and reggae fans talk a big game when it comes to multicultural-ism, but you don't know from diversity until you've transformed yourself into such a confusing medley of racist stereotypes that even the Klan is like "Wait a second, do we hate this kid or what?"

This is the kind of photo you find crumpled beneath some socks in your uncle's dresser and the pit it carves into your stomach is so deep you and Craig Habiff promise never to make fun of your cousin's stutter ever again.

This is a variation of the "Boy Named Sue" school of parenting where, instead of teaching your son to grow up tough, you accept the fact that he's going to end up a psychologically mangled train wreck of a pussy and see how bad you can make it.

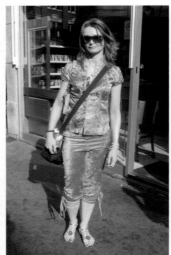

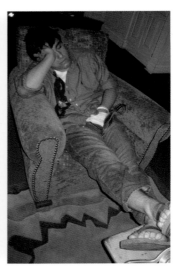

Stop making that corny "man playing the world's smallest violin" gesture whenever you have to listen to some saddie's sob story. We're phasing it out for Richie Basements and his two-string dumpster ukulele.

The big new trend with sexual predators is this thing called "sense-of-touch rape." What you do is keep cramming different textures on your body until looking at you feels like dragging your fingernails across a seatbelt.

A lot of people are like "So what if someone occasionally wears a pair of sandals or goes out with their shirt untucked? It feels good, let them do what they want." They don't realize that these things are gateway steps to becoming a full-blown comfort junkie.

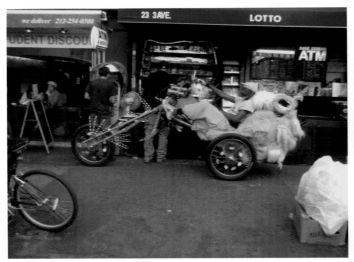

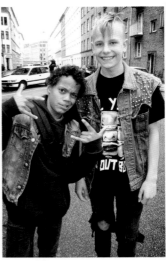

This guy is like one big middle finger to all the losers who think extending the fork on a bike makes them "zany." One big, skeletal middle finger dipped in monster.

Apart from the Fall Out Boy shirt, Junior HR and JJ Cro-Mags are pretty much 100% perfection. Shouldn't Larry Clark be lurking in the background with a camera?

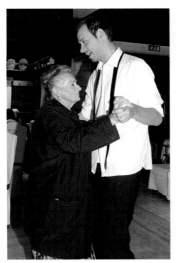

Older chicks rule because their apartments are always clean, they know how to cook a nice meal, and they act super-grateful when you eat them out.

The best thing about kids who are raised in Williamsburg is that they know first-hand how boring creative white people are. They didn't have to learn it from a blog like the rest of us.

Does anything say "suave, eccentric billionaire on holiday" more than a slightly battered vintage briefcase and a perfectly coordinated leisure/flight suit?

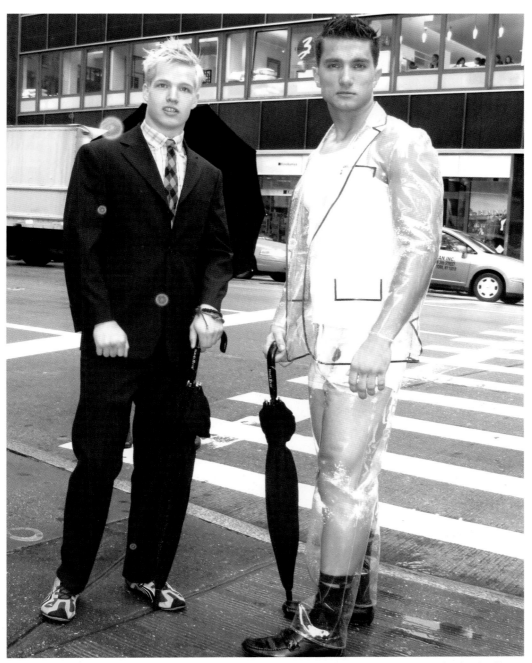

If male models could see what complete fucking idiots they look like to the rest of the world they would die from barfing from laughing.

I haven't had a lot of problems with early-80s LA death-rock girls on the jogging path lately, but pays to be cautious.

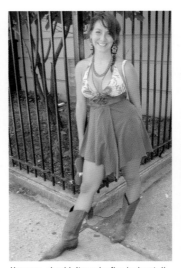

Hang on, shouldn't you be five inches tall and gyrating on some Hawaiian's dashboard instead of wrecking my ability to get anything done for the rest of the day?

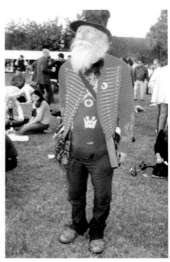

Being reincarnated as a puppet you made on acid may sound like a terrible idea for an afterlife, but that's only cause you didn't come up with Dr. Teeth.

Hey, you've worked hard all day and if you want to mix yourself a pineapple-soda-and-Popov cocktail on the way home, who's to stop you? The world is your oyster, my friend.

With all the freshly arrived foreigners running around Canal Street in square-toed shoes and garish Tommy Hilfiger bootlegs, it's a relief to see someone taking it back to the original FOB style.

I don't want to marry her or anything, but Drea de Matteo with Fran Drescher's hairline wearing her little ass-hugging party jeans will do just fine for the 15 seconds it takes me to bust a nut when we're fucking in the bathroom about three minutes from now (in my dreams).

"No, it's nice. There's all these young girls and the sun's not too bad... Oh, you meant me? I'm just the same old shitty Carl."

Look, if you want to be a Japanese surf-elf who thinks it's "punk" to shave your legs and spend all day accessory-shopping in Shibuya, that's your call. But making your dog huff glue is plain fucked up.

It's sad when a couple can't have children and the woman is forced to dress up and pamper a lap dog or a kitten as her sad little surrogate baby. But do you have any idea the kind of human tragedy that occurs when a couple can't have pets?

Like the proverbial girl who won't shut her yap about how to give a blowjob, reading a freshman-year philosophy book in public is the surest sign of a man who knows less about life than an Australian Chili Peppers aficionado.

Staying punk into your 30s and still being a giant dick in a leather jacket seems like a great idea until you start getting up there and realize just how literal the "giant dick in a leather jacket" part is.

If the music industry doesn't want to collapse by June they should hire more guys like this. They'd come free with Neil Young reissues and visit your house with some weed and an eightball every time you played *Tonight's the Night*.

Awww, how "First Day of Punk" is this girl? The Butt-Head button, the fresh tattoo-less arms, the fucking Batman earrings—you just want to stand her by the door with some kids from the bus stop and burn through an entire roll of film.

Being punk or a skinhead for life seems like a tall order of business until you go to Japan and see people who have been rockabilly so long it's become their last name.

This British public-schooler's smirky bravado may seem out of place, but when you factor in all the tablings and ball-blackings and bogwashes they've been through, they're basically the Navy SEALs of the international nerd community.

I bet more people would be cool with the paparazzi if they went for this guy's "upper-class Malaysian bug collector" vibe, rather than "pack of Brazilian rapists."

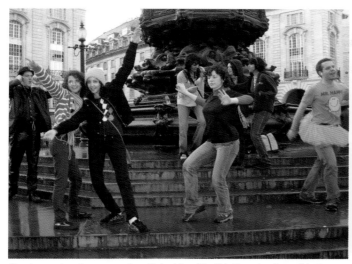

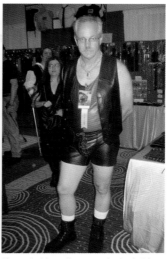

If you've ever heard someone going off about how "the kids these days" are all boring, attention-starved pains in the ass and been like "Who is this guy even talking about?" we're pretty sure this is who he means.

If your dad is really vague about what he does for a living, spends a lot of time hammering things in the basement, and leaves town the third week of every August, you might want to do yourself a favor and visit this year's FetishCon.

Dude, we get that you're willing to jump through hoops to show how much you hate your dad, but turning your ears into jump-throughable hoops just makes the rest of the world think "Hmmm, maybe that drunken, perpetually farting oaf had a point."

Instead of taking inner-city kids to the country to teach them about farms, we should just make them dress like closeted 14-year-old farmhands using their mothers' maternity dresses as dusters. They may not learn anything from the experience, but holy shit would it crack me up.

I never understood where that phrase "Don't blow a lot of smoke up my ass" came from, but I get the feeling this guy might have had something to do with it.

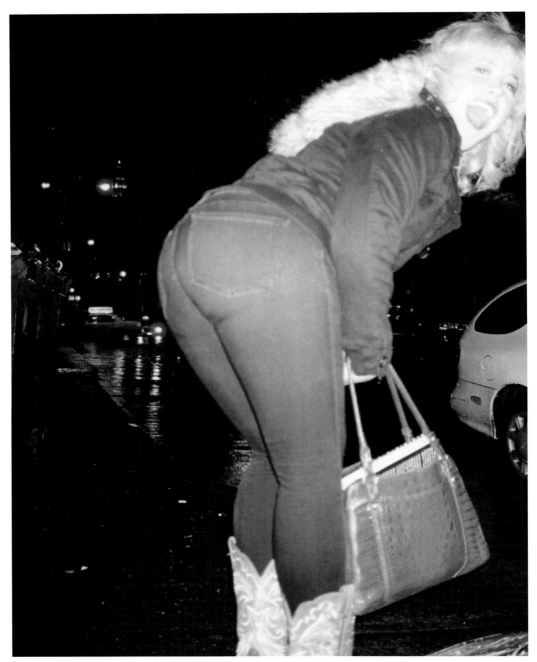

The downside to finding out how cool your mom used to be is it's basically an admission of guilt for making the rest of her life suck.

Remember when Ja Rule was the biggest rapper in "the game"? What the fuck was that about?

Doesn't he remind you of that nursery rhyme about the condiment man who lived in a shoe filled with so many world-music albums that all the king's horses and all the king's men couldn't get him inside a vagina again?

Something inside me wants to molest this Trevor Brown painting come to life but that's a part that I keep buried in the tiny, padlocked box at the bottom of the three-mile-deep closet that's inside another closet that you get to by taking a right turn after skeleton 895 in closet 57.

Ever met a man who uses fake tan who isn't a greasy liar that would stab you in the back given the slightest opportunity? Me neither.

Fuck having a family.

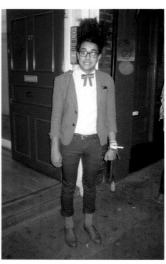

One way to tell your life is on the right track is if you're still using the same strategy to get laid you came up with when you were seven.

Basing your entire look around being surprised to see me is so flattering you might as well be dressed as a morning blowjob.

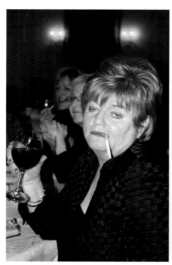

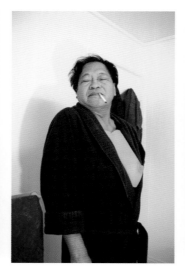

It may not seem fair but some ladies just have an inborn regality, and that's something all the valium in the world can't take away.

Shit, sometimes it's not even ladies. Sometimes it's your Thai friend's rich uncle after 14 beers. Genuine class always shines through is what we're saying here.

A lot of girls act like there's some womanly secret to figuring out a guy has a big dick, but sometimes it's pretty damn clear who's packing what.

Can you imagine how dumbfounding it is to be one of those private investigators who spies on people for insurance companies? Your life would be one perpetual "Are you fucking kidding me?"

Yeah, that's what the world needs right now. More of your cum in it.

Back in the 70s the future was all molded plastic and skintight jumpsuits and dystopias based on having too much sex. The next two decades are a little hazy, but from the way it turned out looks like they involved the back of a paneled van and roughly 2- to 3,000 canisters of nitrous.

Some social issues are just tailor-made for a particular medium of expression. Such a marriage is street ballet and tree-ocide.

How come aging East Village vets always have this smirky, "Seen it all" demeanor even though "it all" can usually be summed up as the same barback's decaying pussy once every couple of months?

Oh good. Looks like the pictures finally came back from my future honeymoon.

People think that acid casualties are all a bunch of homeless bring-downs, but some of them go on to do great things like host a cooking show or psychedelify the fish-bait industry.

This is what the world would look like if more time travelers set their sights on gangster rap instead of baby Hitler.

Laugh all you want, but if you knew how difficult it was for scat fetishists to find an enthusiastic female receptacle in this city, you'd give this girl credit for putting her neck out there.

The Black Israelites have been winning a lot more interracial street arguments since they recruited Afrika Bambaataa's well-read nephew.

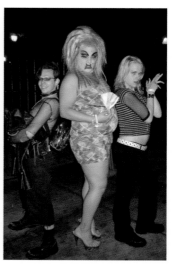

Have you seen drag queens lately? They all think you can just throw a ponytail and sweatshirt over a pair of Asics and call it being a woman, which makes it extra special when you finally see someone taking things back to the Divine days (even with the Sandymount High School civil-liberties club tagging along).

She kept trying to tell us it was OK because "it's traditional," but I don't know of any culture that's cool with shitting in public.

If parents really want kids to lay off the drugs for real they should book these guys on a high school tour of America.

Clearly whoever came up with "the South will rise again" didn't have boners in mind.

Could Los Angeles be any more clueless as to how much the rest of the world hates its guts? It's like they've based their entire existence on living out the jokes we were making about them three years ago.

What the fuck is your problem? You've already tyrannized the bathroom and kitchenette, now she can't even fuck in peace in her own bed? Screw bad room-mate, you are basically the mom from *Carrie* right now.

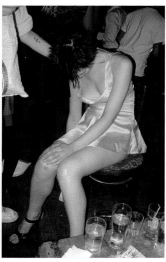

If you're really into shy, twitchy guys who show up at the bar by themselves but are having a hard time getting their attention, try dressing up as date rape.

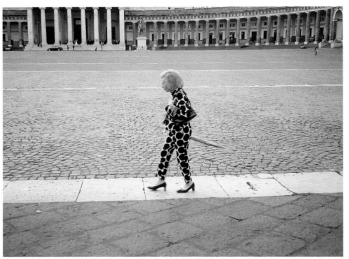

A tear filled my eye as I watched this lovely old bat nobly hobbling off to the patisserie. Why don't they make people as good as this anymore? Maybe we should have some more world wars.

In London we're noticing a lot of these French spies from World War II. All we can say is: "The red sparrow has fled the nest. The next full moon belongs to Smiley."

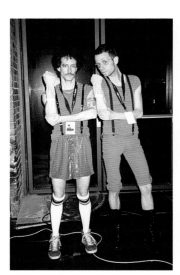

Painful at first maybe, but after applying Human Hemorrhoid Remover my asshole feels brand-spankingly, sparklingly, tingly-tangily new.

We generally don't like twinks, but this is kind of OK. Anyone who can mix Andrew Cunanan with *My Own Private Idaho* is at least worthy of a little back-bathroom tickle party.

Fuck being thin and good looking. Most girls just want to hang around with plump bearded guys who are hilarious at parties and always have coke. If this guy was famous he'd probably be able to fuck them too.

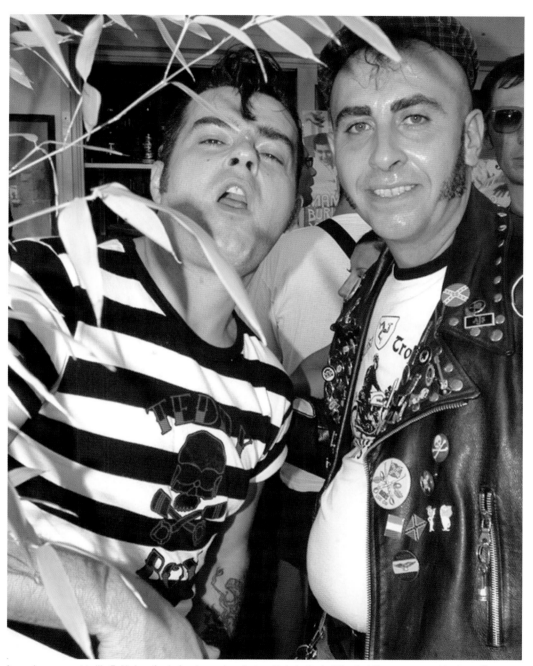

As much as we want to like Teddy boys for de-fagging mod, we just can't shake the fact they look like someone combined a welfare production of *Bye Bye Birdie* with the opposite of a beauty pageant.

We were about to write this girl off as yet another Rollins-era day-tripper when our dick slapped our brain in the face and was like, "Are you out of your you?!"

Combining copper complexion with fish eyes and a vague American Fascist sensibility may not have the guys beating a path to your bush, but it makes anything that comes out of your mouth sound like the cool voice of reason. Even some Earth Crisis bullshit.

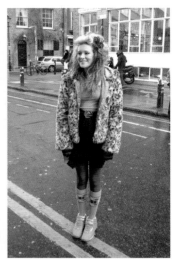

Using Cyndi Lauper as your thrifting template is easy enough, but pulling it all together without a hint of cat-shit-induced mental illness is what makes her the Palos Verdes Blue of girls.

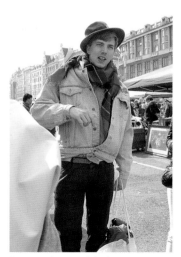

Some people pretend they've never watched *Nathan Barley* while others embrace the fact that they're smug, spoiled, wisecracking dickheads and make the most of it.

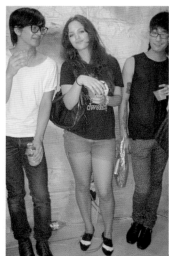

Faggy can be rough when it's 5 AM in a back room of the Cock, but if you can get it to just the point where your life looks like the cover of a Beat Happening album, there's no touching it.

It's a DJ's job to start trends and if that trend is making your hair look like an Irish girl's cunt then so be it. Don't stand in the way of progress.

They want to pretend it's 1983 and they've just stumbled out of an abandoned building where they copped dope along with Richard Hell from a teenage Puerto Rican hooker. In reality it's 2009 and all they're fretting about is where the best place is to score a vanilla chai latte mocha muffin before yoga class.

How infuriating has it gotta be to work your ass off for half a century making everything work better and look more futuristic only to have this shitstain roll up and go, "Eh, I liked stuff better when it sucked."

If you think all the precious man-childishness going on with indie rock kids is a bummer, do yourself a favor and stay away from Australia. When ecstasy hit that country it went off so hard it basically turned an entire generation of ferals into Nick Jr.

It's sweet that his teenage mom saved up enough money to send the little trooper to progeria camp, but those shoes still look like something a pair of crocs barfed up.

Christ, are you seeing these pupils? If bad trips are ever looking for a spokesperson, we are forwarding them her email.

Maybe you think mustaches are "played out" or "gay," but some couples need them to remember which one's got the dink.

See? This is what a real nerd looks like. Someone with about 30 arcane hobbies and some sort of weird gum thing who has no idea what she's doing makes us want to open up on her with a firehose of cum.

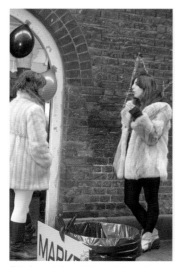

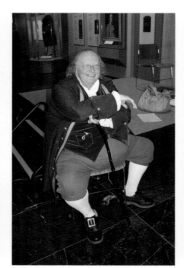

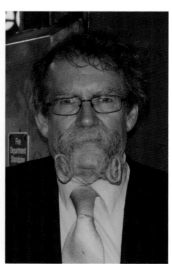

This fur and tights thing girls have been doing lately is so saucy and Londonian it makes me want to get black-out drunk in another country's capital then yell at a stewardess.

Living historians are cool because they cut through all the boring textbook shit and get straight to the real dirt you want to learn about, like Lincoln's gay lovers or Ben Franklin's colossal gunt.

Something tells me these jowl rings are exploiting a major loophole in intraoffice facial hair policy and if that stuff-shirt Anderson's got a problem with it he can blow it out his ass.

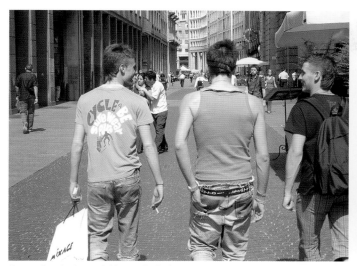

Can you imagine how weird it must be for fags to go somewhere like Milan, where they're actually 130% straight?

Probably the worst part of going home with Grace Jones is how often that bitch'll walk right out the door wearing your shirt the next morning without even leaving you any juice.

Seconds after this picture was taken the sidewalk opened up and a miniature rocket closed around him before blasting off to Ska Base Alpha. We thought we were the only ones who saw it, but then this bum wandered over and said, "[pause] Whoa."

Forget false metal, someone really needs to call for a death to false nerds. We're talking about these frat guys and regular bitches who saw Juno and decided to retrofit their boring personalities with a bunch of shitty cartoon characters and video games they don't know the name of.

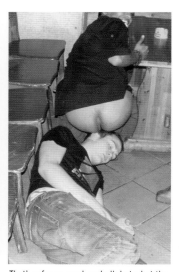

That's a funny prank and all, but what the fuck is going on with your ass? It looks like Homer Simpson is kissing your friend good night. Seriously, what do you wipe with, more shit?

Dragged away screaming is still obviously the industry standard, but we think led spacily by the arm with a sliver of jizz on your chin has a refined sense of debauched insouciance that could make it a real competitor this year.

My Spanish is a little rusty. How do you say "*Vrum, vrum, vrubububububababam eeeeeeeerrmrummrumm eeeeeeeeeeeeeeeer- huhmeeeeeeeeeeeeeee eeeeeeerrr- huh-meeeeeeeeeeeeeerr -ERRRRRRRRRRRRRK!*" again?

Spring is a special time for teenagers in New York. The days are growing longer, school's winding down, and once again the world is their parents' living room.

There's no real "right" time to grow dreads, but it's definitely the wrong time when the rest of your hair is so slimy and decrepit it looks like someone fixed a rope to your scalp with monster snot.

One thing I like about Sasquatch is, no matter how down on his luck he gets, you just can't shake his national pride.

These new abortion ads are getting a little harsh.

Wearing a mishmash of 10 different textures is like taking our brains on a field trip to the Petting You.

The great thing about Japan is even if you don't make it as a doctor or a salaryman that doesn't mean you're out of the running. You just go the opposite route and end up Oishi, the black-out king of Hokkaido.

Nerds like Stanley Kubrick think the CIA has a stable of brainwashed sex slaves for old politicians to fuck. This seems like bullshit when you're googling "Project Monarch" at 2 AM, but when you see one doing her little marionette dance in the wild, you will doff your tinfoil hat in awe.

We're turning over favorite uncle duties to the guy who responded to "You know what Freud would say about that cigar?" with "No and you tell that queer he can suck my mom's dick."

Slightly floppy-haired boys with all their shit together and maybe one or two little splashes of mod like a Tootal scarf or a pocket square totally make the best lesbians.

If we have to hear one more pussy complaining about how cold it is and where's Summer and when's Summer going to get here, we're sending Summer over to sort things out.

You can tell you've picked the wrong borough to live in when even homeless people like to shit on it.

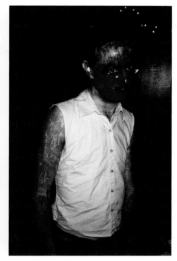

Some people claim that blue balls is a myth, but trust us on this one. If you let those pipes build up for too long, it will blow up in your face.

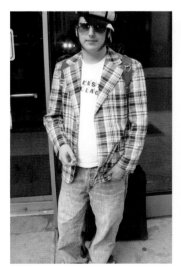

This is the kind of thing that happens when a kid grows up in a place so white and rural that the only chance he has of becoming a wigger is to cobble something together from old episodes of *Good Times* and his parents' Commodores records.

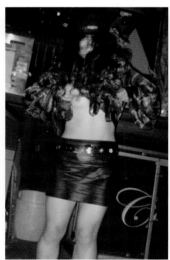

We're all for crazy dancing, but there's a fine line between "cutting loose" and turning yourself into the misplaced-tit demon from *Jacob's Ladder*.

Do you ever get the impression that fashion is just some aggrieved fag's way of fucking with all the guys he couldn't fuck in high school?

Here we go. No more shaved chests and frosted tips. Jock's going back to packs of troglodyte heshers in letterman jackets and anybody who's got a problem with that is getting their buns taped together within an inch of their ass's life.

When you factor in all the time spent fashioning necklaces from fragments of people's skulls and pushing hundreds of nails through leather gauntlets, black metal is just an extended crafting circle with occasional flute intros. We're glad to see someone finally admit it.

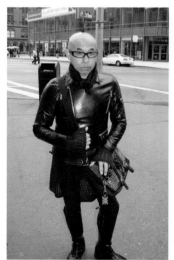

The reason people love pictures from the 80s is the film makes everyone look like you've just done poppers on top of eight or nine beers.

Most midlife crises end up so deep in convertible-and-ponytail territory you're like "Have you updated your definition of 'cool' since you were five?" When you see someone who's hit 35 and become a Klaus Nomi biker-punk, though, you know they've got their priorities in order.

Running into a white Ronnie Spector with limited tattoos after a night of drinking is the sort of thing that can completely derail the relationship you've been building with that girl you usually beat off to.

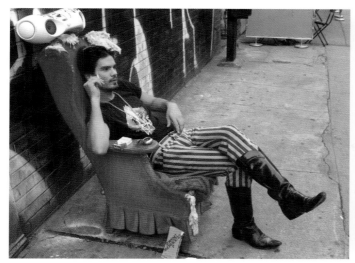

Wow. Carrying around a jambox is one thing, but how into yourself have you got to be to set up an entire throne for your personality and read *A Clockwork Orange* while smoking cigarettes (he even brought his own little pocket ashtray with lid) like you're living out some 8th-grader's detention fantasy of what living in New York is going to be like? The bottom half of his mirror must be permanently frosted in jizz.

Evidently this marketer's wet dream doesn't realize that having blue flames shoot out the bottom of your shorts just makes it look like you want the world to know you're never not farting.

Kids think being a hitman is all luxury suites and assembling rifles on the roof of the UN, but that's because movies never show the "paying your dues" phase where you have to reuse the same piano wire and leave enough time between garrotings to get the milk into the fridge so Lois doesn't bite your head off.

It's mind-boggling how in the space of 20 years Milan has gone from dominating the fashion world to skiboarding onstage shirtless in a pair of Ted Nugent visors. Do they put coke in their drinking water or something?

It's always uncomfortable seeing someone famous in a place where they don't know anyone. You can feel everyone in the room straining every muscle in their body just to keep from saying something like, "Man, you look a lot sadder than you do on all those Icee cups."

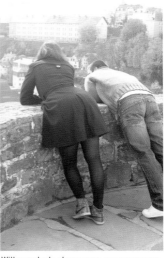

Giants suck when they're clubbing your friends or chewing on the side of an uncooked sheep, but once you get a couple pitchers into them, they combine the robust charm of your standard tranny with the genteel flutesmanship of the guy from Jethro Tull.

Will somebody please pass me a magnum of champagne so that I might christen the SS *Ass Worship*?

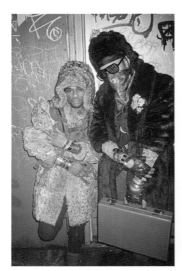

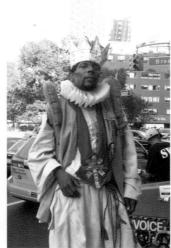

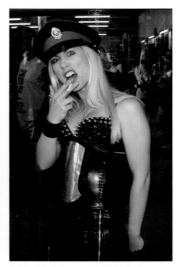

Finally, someone even approaching futuristic enough to pull off those damn Kanye glasses. These guys look like they just carried out the most daring nuclear bank heist in Neo-Siberian history.

How come you never see white crazies approach their mental illness with this level of flair? Is it the centuries of having to make lemonade out of lemons or is there something in melanin that kicks in when the rest of the brain shuts down and crowns you King Sofa the Third?

A lot of East Germans act like they're nostalgic for the old DDR because Communist life was more orderly and stable, but we think they just miss the days when their chief national export was überaryan monster doms.

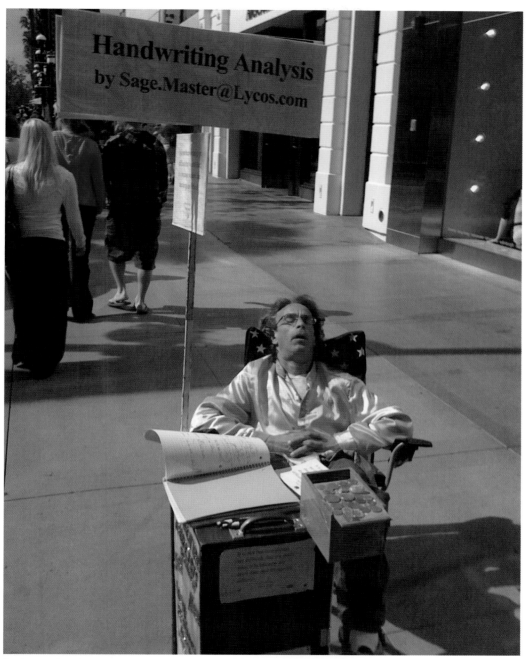

It takes a particularly dedicated brand of laziness to get fired from a job you made up for yourself.

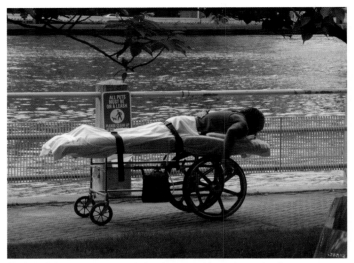

Murderball players are pretty tough, but they got nothing on human javelins.

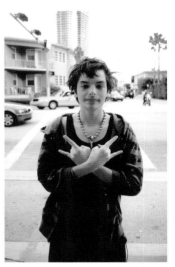

How about that glorious period called 18-to-20 when you stumble from party to party reeking of sex and booze and all you have to worry about is where you left the number of the girl who gave you ketamine last night or whenever it was.

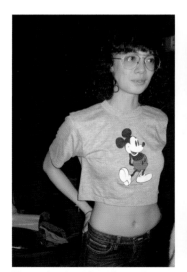

Whoever introduced South Bronx roller-skate nerds from the 70s to funny English girls from the nows deserves this year's Fritos-and-Ice-Cream Prize in the field of Novel Combinationing.

Oh, you think you've got balls because you went out in a shirt with a girl's tits on the front or some joke about drinking? Try wearing an ensemble whose punchline is your entire life.

Putting bare tits in overalls is always going to invite some rude approaches, but shrinking it down to linger-alls be pre-pared to spend your night fighting off the endless waves of boner wolves.

The picture's a little blurry, but isn't it a good illustration of that moment when you're 14 and have to make the painful decision between sticking with your childhood friends and looking like an absolute fucking moron?

Guys who actually think with their dicks can be pretty rough on the eyes (and ears and nose and brains), but they've got nothing on the girls who think with guys' dicks.

After years of failed experimenting with short shorts and the tops of our asses, this groinal pioneer may have finally discovered the elusive male cleavage. Get ready for summer, because you are about to get ten times more laid than you know what to do with.

You know when the DJ has just pulled some insane cross-table double-record-scratch and everybody's screaming, then the bass comes whipping in like zooooo0OOOOSH and it feels like a sweaty man in chaps is forcing his entire balled-up hand into your asshole? That moment is what Belgian techno fans live for.

Oh I'm sorry, it appears that I've gotten lost. Can you tell me how to find my way out of the brain of an autistic tween trying to masturbate to a shampoo commercial?

Sure, the Dominican Republic is the North American hub for human trafficking, but look where it's got them. If you had such a fuckable national resource, wouldn't you want to sell off some of the surplus?

Maybe there's something in the water (besides raw sewage), but Indian kids are having higher and earlier cuteness peaks than white kids. Sorry, baby Parvati—it's all downhill from here.

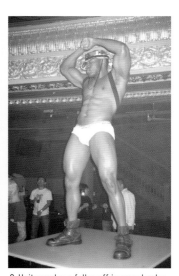

Heroin hasn't done much for aviation or particle physics lately, but the field of avant-garde hat design is deeply in its debt.

Burkas may be an affront to women's rights, but if you were rape-married to the Saudi Gomer Pyle, you'd be pulling this thing over your head with a huge sigh of relief every time he dragged you out in public.

G-Unit may have fallen off in record sales but at least they're still out there hustling for that paper.

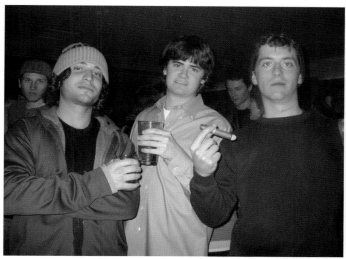

The only thing worse than an 18-year-old boy is a 22-year-old boy. Look at their slimy man-child faces, awkwardly smoking cigars and ordering grown-up drinks that they don't know the ingredients of. We had to get out of there before they started telling us how "mad crazy" the recession is.

Say what you will about steroids. At least they keep Muscle Beach from looking like *Rent* with sand.

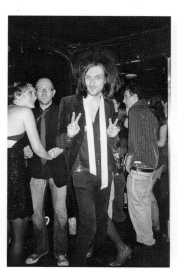

These jean wars have really got to stop. All the waffling between tight and baggy has left the vanguard of the pants community looking like two midgets trying to sneak into an r-rated movie.

If your life is so shitty that you have to dress up like a famous person just to get out the door, can you at least pick one that doesn't make the entire world want to choke you to death with your skinny little scarf?

Oh look. It's a production still from the new season of *Black Dudes Fuck the Darndest White Ladies*.

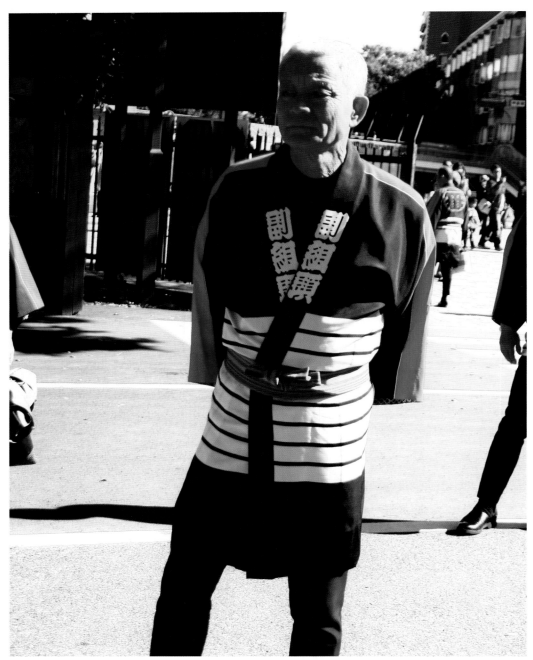

Did you know this is what firefighters in 17th-century Tokyo looked like? Evidently they'd just vibe the flames until they went "OK, sorry, we'll stop now."

For those about to double-team the 45-year-old Mexican barback for coke, we salute you.

Whatever, you're all just jealous your life didn't turn out exactly how you pictured it at age 12.

If wealthy, cheesed-off boomers are going to host fake Boston Tea Parties over the mortgage bailouts (PS: corrrnay), we should at least be willing to reduce a couple longboards to splinters over a quarter of our paychecks going into the cargo pockets of 80-year-old Dennis the Menaces like this.

That Christiane F., rained-on junkie-runaway thing is great for your early teens, but past 20 you just start looking more and more like "weekend mom."

Evidently getting nuked within a trace of your gender is very fashionable in Brussels this year.

Now that cops have switched from guns to tasers, the only option left for lazy, depressed people is "suicide by jock."

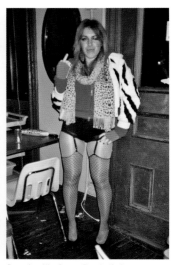

Dressing like Peggy Bundy if she put on all her clothes with a cannon is such a rude mess of drunken perfection you can practically feel the thumb up your asshole just looking at her.

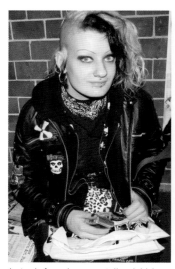

Instead of growing a ponytail and driving around in a PT Cruiser, why not focus all your midlife-crisis energy into hunting down facsimiles of all the girls you never got to fuck in high school? First on the docket: that older girl at punk shows with whatever-the-hell-her-zine-was-called.

The statuette for the annual Here's The Guy awards, or "Guy-ies," was going to be Bruce here with a hundred 20-bags spewing out of his hands and pockets, but we had to tone it down for the sponsors.

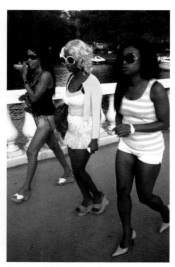

Jesus, could these three have summer any more under control? Even their negatives are making me wonder how hard it would be to fake owning a yacht.

What's that? Oh, your head hurts? It's bright in here? Walk it off, you fucking baby. Until you've experienced the full ass-wrenching horror that awaits you when you drink any more than three beers after age 30, you are not allowed to say you're hungover. You've got a "timmyache."

This was a prototype "visual stimulant" doctors were developing to replace that little rubber hammer they use to test your reflexes, but they had to abandon the project because people were kicking way too hard.

Oops. They got so excited about inviting all the races to take part in their little collegiate cuddle party that they forgot to check with any other races and see if they want in. (They don't.)

You may think he gets a pass on looking like a Fisher Price man-child because of the stroller, but age 1 to 4 is the period when you learn to differentiate between grown-ups and shitty rubber chew toys.

It's kind of amazing that in this age of globalization and Western cultural hegemony there are still entire scenes of ethnic artists no one cares about, cranking out terrible music for no one to listen to on instruments that may not actually exist.

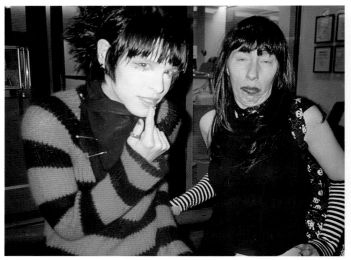

If you want your Gran to stop being such an old-fashioned grouch just find a way to get her out of the house and show her what kids are into these days, like taking her to a hardcore show or one of those emo sex-parties she keeps hearing about.

Ever have one of those shits that's so awful you've already gone through three-quarters of a roll and then suddenly one last piece plops out and you're just like GAAAAAR-RRRGGGGHHHHH and just start smashing everything you can lay your hands on? Really? And here I thought it was just me.

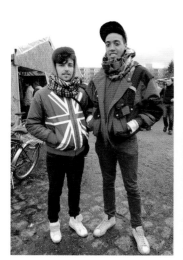

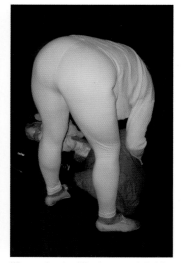

Having a tall friend is great in a fight, because he can come in and absorb all the punches. But having a tall friend who's also willing to absorb all the fag-bashing that leads to the punches is about as close as it gets to having your own personal stunt double.

If you've got some sort of degenerative spinal business that makes you look like a cross between R. Crumb and a fetal shrimp, you should go for a casual mod vibe. That way when people take your picture, it just seems like you're maybe dancing.

When you're stumbling home wasted at 3 AM, nothing beats having a giant ghostly marshmallow ass appear like a beacon in the darkness to guide you safely in the direction of food, pillows, and a dirty sock to jerk off into.

Buddy, I'm not one to talk when it comes to sexual hang-ups, but if getting off requires a homemade floor costume, explanatory cards for people who step on you, and showing up to the party 15 minutes before everyone else just so you can set up shop, you might want to consider what led you beyond the realm of squirting Lebanese bukkake MILFs.

I don't know where the American South got its reputation for being especially "trashy." If you take the train 30 miles outside any city in Europe you'll find families that make your average NASCAR attendees look like albino Huxtables.

If she was a foot shorter this coat would have dramatically different connotations, but right now I'm about 90% sure the intended message is, Why are we driving into Linda's back?

He's moving the hat from right to left because tonight's the night he graduates from prick to full-on shithead.

When newly out dads ditch their families for Frisco and squeeze their 50-year-old buns into a pair of biker briefs and head to the pride parade it's so here, queer, and used-to-it that they give the whole city a hard-on.

Making friends in a new town can be a dicey proposition, especially somewhere with a bunch of arcane social rules like Japan. Your best bet is to throw back about eight or nine shots and just follow your gut from there.

It's nice when people go to a lot of trouble putting together a perfect weekend outfit cause it shows they care about making the night something special, but our hearts still belong to the last-minuters who dive through a pile of clothes and are ready to rampage.

I just showed this to the guy who sits next to me and he was like, "The only way this girl could be any more of a fantasy wife is if that crown was in the middle of a giant Brunswick bowling logo." And I was like, "Who are you, Al Bundy all of a sudden?"

So many people have jumped on the Sarah Silverman bandwagon recently it's nice to run into an OG fan still keeping the flame.

Either he's afraid of blowing his day job in the Goldman Sachs IT department, too tall for his tanning bed, or gays have finally reached the point where I officially give up on ever understanding what their deal is.

You've got to be the most unlucky photographer in the world to be facing the wrong way when an atom bomb goes off.

This looks exactly like the first photo the press would run of the girl some senator buttfucked on a fundraising trip to Atlantic City and it's making me want to run for office like you wouldn't believe.

This guy may get my ass laughed off walking down the street, but in the context of the fashion industry, greasy Phil Spector gnome with a beard made of glitter is the best way to show everyone that you know what you're doing.

This outtake from G. Gordon Liddy's 2009 *Stacked & Packed* made us go, "Ugh, 'girls with guns' could only appeal to a guy who spent the 60s beating up his kids' hippie friends and trying to firebomb the Democratic Party headquarters," but then we were like, wait, that guy rules.

Tommy Chong's been a bit hard to handle since moving to Japan, but honestly, we're just happy to see him enjoying his golden years to their fullest.

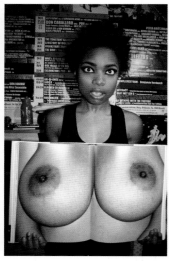

Feminists and Joe Francis have made it so the only time you can ask a girl to show you her tits without feeling like a rapist asshole is when she's carrying them around in a book.

Living up to your t-shirt can be as simple as knowing a lot of dick jokes or getting really drunk, but every so often it comes together in such a sublime combo of personality, weird local politics, and probable mental illness that the only valid response is "OK, OK. Are this place's tacos any good?"

Ugh, the only thing worse than nerds who hate parties and drinking are the ones who love them.

Sometimes when a person finds out they've been put in the DON'Ts, they'll get all worked up and call the Vice office and try to harrass us into taking their picture out of the book. Others just take the easy route and invade our nightmares.

We appreciate the warning, but wouldn't it have been easier to make a shirt that says "Ask me about my hilarious beliefs concerning that 2012 shit"?

I'm not sure which is worse anymore: Trying to use a computer so shitty it falls apart the second you put a CD in it, or having a working machine but being forced to take part in a bunch of one-love bullshit that's even cornier than the Dalai Lama's bowel movements.

Nobody's saying you've got to be Brad Pitt to get laid, but when you walk up looking like a lunchsack puppet some wizard brought to life for his kid, the sound of vaginas clamping shut is like machine gun fire.

All those ad agencies were right. Cigarettes and shades can make any asshole look like a totally cool dude.

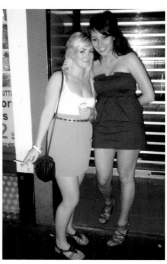

Is the one on the right levitating or has all the blood in my eyes and brain just bolted for my dick?

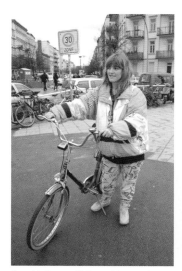

Poor, kind, crazy Claire and her psyche held together with cobwebs. Even when times are rough, she will always lend you her unicorn.

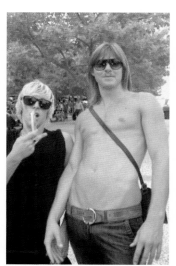

"Porno chic" is maybe the corniest, least sexy thing on Earth, but dressing up like John Holmes's bendy cock is taking shit to a whole 'nother plane.

The only people who can still do subtle candy raver without looking like their skull is a symphony of cracking synapses are South Asian girls in London. We know it's not fair, but they've just got the right skin tone and eye shape. It's like black people and purple.

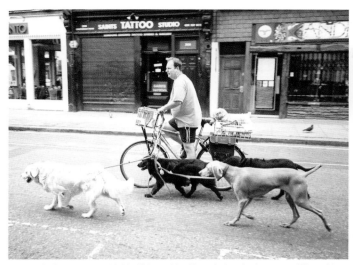

Look at the Beastmaster with his 20-legged barking, pissing, farting, ass-sniffing, shitting-on-the-sidewalk machine. Couldn't he have just gotten a bunch of muscle cars to compensate for his five tiny penises? Or one of those Cheap Trick guitars?

Don't worry about it, Hiroki. If you need to take another breather we can totally wait up. These paved, perfectly level walking plazas two blocks from the house can be a real bitch sometimes.

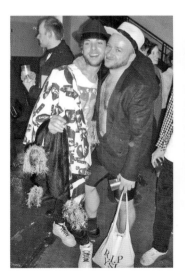

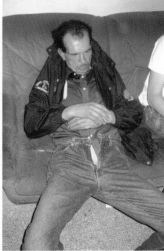

Sorry aging fashion guys, but there's nothing fierce about 30 pints of dick cheese fried up in a burning ball of hair.

Party tip: Girls don't like guys who try too hard so be yourself and relax. Soon you'll be beating back the cooze with a spiked bat.

You know, it seems like every time I go to the store they've made another variety of jerky.

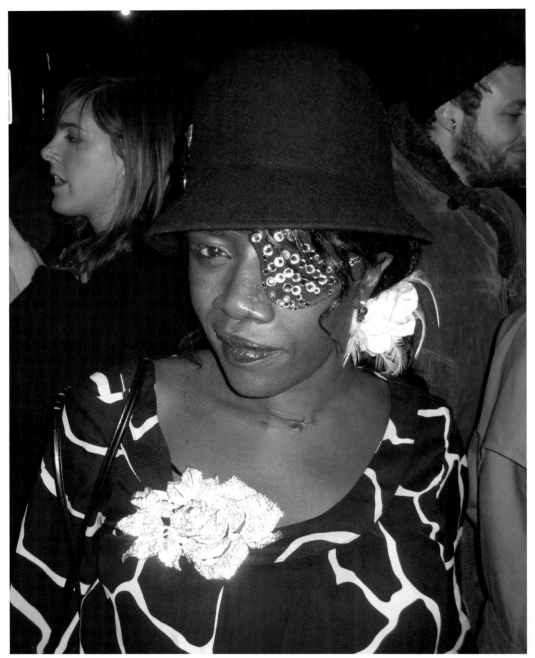

What's that? Oh, you can't go out because you've got a big zit on your forehead and your hair's "being weird"? This bitch had her face macheted in half and she was back in action in the time it takes to bedazzle an eyepatch. Please.

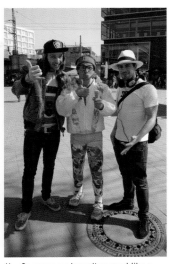

"Ground Zero is the first stop on the Terror Tour. Next stop: the Foot Locker where Richard Reid bought his shoes."

Hey Germany, we know it seemed like a good idea to get rid of all the skinheads after they started beating the shit out of the students, but you can't fuck with the natural order of things without there being disastrous unintended consequences. Didn't *Gremlins* teach you anything?

Dear Cheryl, homo stylists make Agyness Deyn's hair like that so men won't find her attractive anymore. And they use qualified hairdressers too. You look like *When Something About Mary Met King Kong*.

You had over 60 years and six continents' worth of subcultures to pick from and you went with 90s guido, five-year-old Van Halen fan, and progressive housist who came to the AIDS rally straight from Twilo. This photo fills me with more dread than watching *The Obama Deception* after downing a handful of gullible pills.

Letting your husband take pictures of your splayed rubbery vagina getting impaled by a giant purple dildo on a busy highway for him to post on message boards as a last-ditch concession to keep him from leaving you for the 20-year-old stripper he goes to see every night must be exhausting.

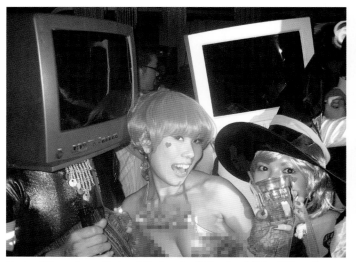

Here's a little number we like to call "Just another Wednesday night in old Nippon."

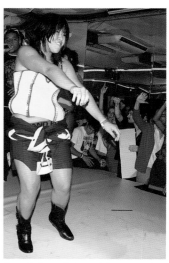

Doesn't she remind you of that expression about a girl having "more curves than a circle," except more literally?

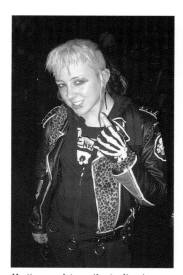

Meeting your future wife at a Napalm Death show is nerve-racking, because in between the ferocious bathroom fucking and mutual binge drinking all you can do is look at your watch and wonder, "How much longer is she going to be on this whole bicking-her-temples trip?"

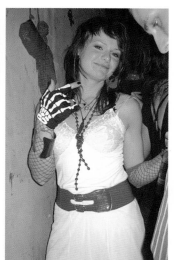

Of course, once the hair finally starts coming in, then you've got to worry about how you're going to get rid of that stupid glove! [*rimshot*]

When something happens to you in a shirt it's important to hang on to that shirt and wear it out over another shirt from time to time so the world will never forget that one time a thing happened.

"Come on, keep playing, Davey. If your head's full of music, there's no room for the thoughts about Mother's sweet silky skin and the glint of the knife as it sta—NO! *Camptown ladies sing this song, doo-da, doo-da, Camptown race track's five miles long, oh the doo-da dayyyyyyy.*"

Fate can be a real asshole sometimes.

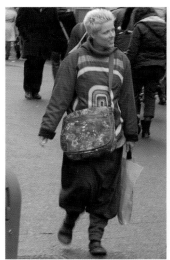

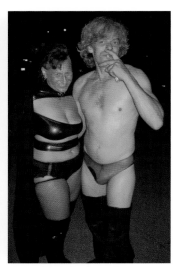

Oh hello, it's the Human Enigma! Just a'riding the rails with his MC Escher legs, lesbian biker jacket, and pants that will be confusing alien archaeologists for millenia to come.

Um, I don't know if you grew up on Dune or something, but here on Earth we try not to dress like a literal bull's-eye for muggers. Also we're pretty big on this thing we call "genders."

Wow, they found a way to simultaneously combine their love of DnD with public sex and my laughter with dry heaving.

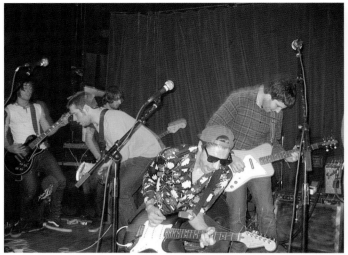

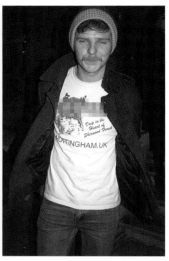

No more keyboards. No more horn sections. No more "additional percussion" or dancers or girl members or people whose sole role in the band involves twisting the knobs on a delay pedal. From now on if it's getting onstage it better have a guitar and testicles and if that doesn't sound right to you, we'll just keep adding more until it does.

Whenever you're in a new place for the first time there's always that fear that everybody will be a bunch of toffs and you won't meet anybody operating on your level. Then you bump into some slit-eyed goon burbling something about stolen chips and you're like, "Ahhhh, my people!"

We've given kids shit in the past for putting too much craft time into their look, but seeing a couple pull back the sheet on zebra punk is the kind of thing that makes you rethink your curmudgeonly ways.

Japanese people are more or less professional picture takees, which means this is either a scientific miracle or the biggest national fuck-you since the Kamikaze.

Is there anything in the world hotter than a set of busted teeth? Not rotting-out-of-her-face bad, but just mangled to the point where you can't stop picturing that one snaggletooth bouncing over your nutsack like "Hi there!"

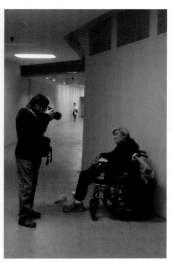

Dear horny guys without a single ounce of shame in their entire fucking bodies,

Please know that the only thing keeping the rest of us from inserting our entire booted foot into the cavity left by your exploded testicles is the possibility that you'd get off on that too.

PS: Thanks for all the web porn.

If you give a man a fish you feed him for a day, but if you post a grainy B&W picture of a man to your photo blog, you make me want to drive a length of pipe into the back of your knee for the rest of your life.

You might think it'd be relaxing to throw in the appearance towel and dress like all the teenage mothers in your apartment building, but if you knew just how much time, energy, and misguided brand loyalty went into looking that shitty, you'd be grateful for your decent taste.

What part of this disgusting pig's brain thinks his penchant for wearing diapers in Amsterdam's red light district is going to disappear the moment this grotesque stag night fiasco is over? People like this shouldn't commit to anything longer than wiping their ass after they shit out that morning's Burger King.

Is it just me or does this guy's extreme male facial cosmetics make you want to throw your hands up and tell him to take whatever he wants, just please... please don't hurt us.

Can you imagine how hard one of those Mystery-worshipping pickup magicians would shit himself if this guy pulled up through a veil of mist saying "Here, let me call you back, Phil, I've just got to deal with something real quick"? It would sound like a buffalo hitting cliff bottom.

I can't tell if he just got to his chest and said "Fuck it," or saw himself in the mirror and was like "Hang on a sec, why make myself a half-assed woman when I can just be half a cool gay dude on top of half a really hot girl?" but it's kind of making me want to do both.

If you can't decide whether to be a mod or a punk or a communist or a hooligan or a girl or a really faggy medieval prince just be them all.

If you were born with a skull so perfectly shaped it looks like the ones in anatomy-drawing books, you owe it to your genes to spend at least a couple years with some kind of post-apocalyptic unicorn-rider haircut. It's what we call the Tank Girl's Burden.

It can take months and even years of having sex with someone to work up the courage to tell them what you're really into, but how great is the feeling when your balls finally kick in and she says "Me too"? It's like the Ohio Express are playing a private concert for your stomach.

Three good questions to ask yourself before leaving the house are 1) does everything I have on match, 2) am I going to be too hot to dance in this, and 3) if I get even slightly sweaty is this dress going to make me look like a human cumshot?

You've got to have balls of steel to go up against the Female Body Inspectors in this town.

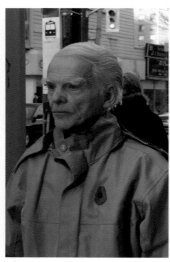

Whenever some old fart starts bitching about how Korea is America's "forgotten war" it just makes us think of our nation's real unsung heroes: the veterans of the TransXanthian Star-Incident on Rigel VII.

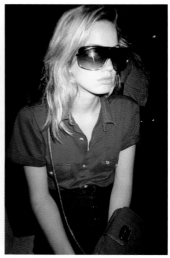

The easiest way to fuck a dumb girl without having your brain melted by two-hour conversations about TV is to convince a smart girl to blow out her hair and not be funny for the rest of the evening.

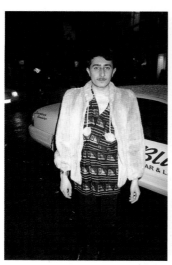

Doesn't he look like he just got caught in the middle of a *Fawlty Towers*-esque scheme to replace a an antique vase or crash some sort of high-society ball? Something about his face just screams, "Mmmm'yes?"

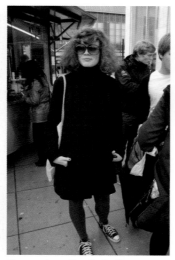

There are two options for 5s: You can spend all your money on makeup and beauty products to bump yourself up to a 6 or you can turn yourself into a funny little cartoon lady and make guys wonder so hard what your vagina looks like it feels like we're trying to hold in a diahrrea.

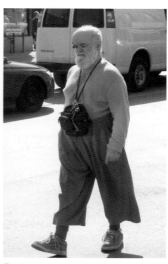

The best thing about the Many Worlds interpretation of quantum physics is knowing with absolute certainty that there's a universe where Ed Asner founded a quasi-Eastern religion based on the abolition of pockets.

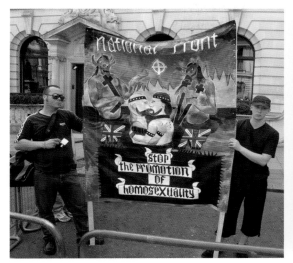

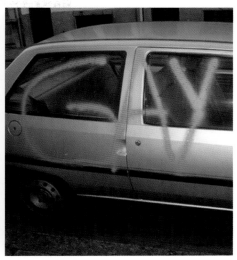

Um, if you're trying to convince folks not to turn London into New Sodom you might want to track down a better artist, cause that crummy Mike Diana ripoff is seriously making us want to fire up some Obituary and see if we can still squeeze into our old cock ring.

That's more like it.

Say what you want about the kind of smarmy, perpetually-unlaid nutcrease who'd actually sign up for a card-playing team, at least professional bowlers finally have somewhere to displace all that pent-up aggression.

Man, trying to keep the CosPlayers straight from the protesters straight from the flash mobbers is getting harder and harder to care about these days.

I swear, if I have to listen to one more of these neat-freak hippies blather on about his non-chlorinated detergent or his intestine cleanser or how spic and span the walls of his anal cavity are I am going to catch his farts, hold him down, and pop them in his mouth.

After putting us through nearly two decades of maternitywear, black teens have basically earned a free pass on whatever look they want. Even chiptune nerd.

He's either pulled off the mother of all one-night-stand escapes, or Inspector Gadget just entered the square and is slowly walking toward the target.

Assimilating to a new culture is all about making overtures to your host's customs and prejudices and if that means doing the local speed until you turn into a cartoon of what they think you look like, well, better start smoking, round-eye.

Right on! If those fucking snack narcs think they can get between you and some delicious frozen treats right now, they're gonna get what's coming to them. You are totally in control of this situation!

Whenever Hollywood tries to pass a 9 in corduroys off as "the weird girl," it makes me wonder if casting agents are really that oblivious or they're just still carrying a grudge against all the thick-necked girls in Melvins shirts they had to fuck in high school.

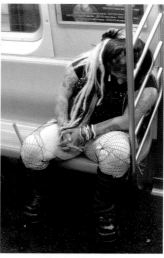

The scary thing about this girl is if you didn't happen to catch her on a GNC run you'd have no clue she was into 40-year-old disco cavemen who shave their arms and still have Poison in their warm-up mix. It's like she's on the douchebag DL.

The one good part of dressing up like a Hello Kitty juggalogre is that most of us have been conditioned since childhood not to disturb your slumber.

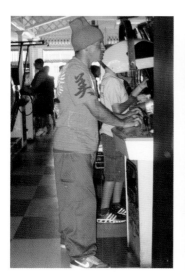

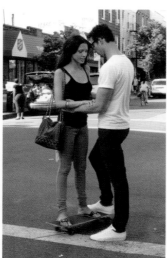

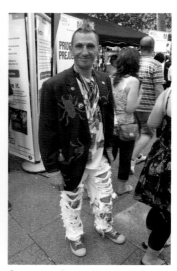

Whenever you hear about some Mormon kid coming to the big city and losing his way it's always "sex industry this" and "meth parties that." Nobody's willing to acknowledge the equally destructive pull of video games and gnome culture.

I know it's a pain in the ass to have a Hollywood crew take over half your neighborhood for a month to shoot some lousy romcom, but when you guys see *The Dirtbag*, I think your heartstrings will be having you sing an entirely different song.

Gays are usually a good barometer of what hetero fashion will be like in the next few months. Judging from this year's pride season it looks like we're in for some heavy divorcé Warped-dad with scattered chances of rave.

Why's androgynous always gotta be some titless stickbug with short hair? Why don't we mix it up with, say, a funny talking horse made out of being stoned?

The Irish may think they've got a lock on sad, terrifying drunks, but you could've replaced Brendan Behan and Teddy Kennedy's amniotic fluid with vodka and still be nowhere near the kind of monstrosities rural France is bringing to the table.

OK, Niagara Falls, I'll see your inexplicable packs of South Indian teens in front of the Hall of Presidents and raise you one black nu-metal fan driving a garbage truck in the Netherlands.

"Look Maria, I know I said I'd bring her back at six, but then we just had to stop by the pier and now if I don't get over to Tino's before he closes I'm going to be dealing with these tangles *all weekend*. Is that what you want, you spiteful fucking bitch?!"

Teaching your kid to fly is pretty impressive, but it still doesn't make up for the racist shit.

Here's a question for all those smug, die-hard evolutionist, flying-spaghetti-monster types: If natural selection's so infallible, how come we're still dealing with drooling Stiv Bators heroin-zombies over a generation after the original got run down? Oh right, dumb chicks.

Our new installation piece is called "America, Served Chill."

When you're reading the comic strip it makes you think "Man, you could not pay me to hang out with this griping, frigid Cathy bitch," but then you bump into her at the bar and realize, "Oh yeah, that's just a character she plays."

What's going on here? Where's the stressed-denim board shorts and screen-printed skulls and the Ed Hardy guayabera? Shit, he's not even wearing sneakers. It's almost as if he's a full-grown man with a job and wife whose purse he's holding (please don't be his).

I don't know where TV stations got the idea that we like having our news barked at us by arrogant blondes in pantsuits, but looks like Mexico's starting to figure out the route to our complete and undivided attention.

Come on, America, we've been at the drunken-yokel game for nearly a quarter of a millennium and what have we come up with? Billy Carter? Ogre? These Belgians are *reaming* us with their 17th-century ringmaster tramps.

Living vicariously through your children was bad enough when it was just balding homophobes who never made the football team. Now you've got parents who wish they'd spent a couple years tramping around the Pacific Northwest dressing their kids up as grunge urchins and making them smoke like it's an Anne Geddes version of *Drugstore Cowboy*.

And I don't care if you're a four-year-old hustler or a Double-Crested Slyzax from Dimension Gorp who just started getting *Happy Days*, cigarettes are for insecure teenage girls and sweaty, middle-aged insurance reps.

We all know how hard it's been on the guys who can't get over their high school football careers (thank you very much, The Boss) but when's someone going to get around to penning an anthem for the poor schmucks who peaked as fifth-grade bullies?

"Those jocks down in AR may think they can push me around and hide my trackball and move my purchase orders to the back of the queue, but they can't touch me now. This is Brian's tiiiiiiiiiiiiiiiime!"

The most satisfying part of asking an aging male-model Charlie Brown grunge turd to pose for the DOs & DON'Ts is the moment he realizes which side of the page he's destined for.

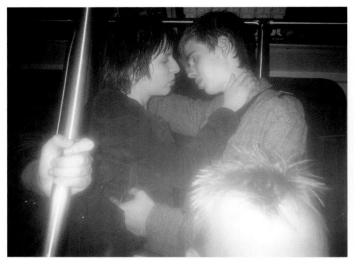

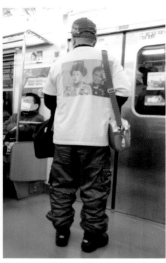

We're not here to point any fingers, gays, but maybe prop 8 wouldn't have passed if you'd spent a little less time grousing about "rights" and a lot more time fogging up our left anterior cingulate cortices like these two.

It pains me that I could go the rest of my life without knowing whether or not this guy is awesome.

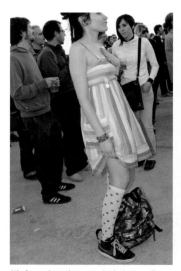

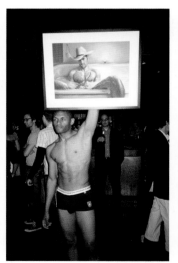

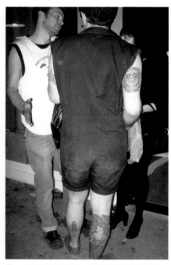

It's funny how the same look that spells out "Psychotic Cutter" in thick red Misfits letters when you're in America morphs into "Perfect Blackout Accomplice" the second you cross the Atlantic.

As frank and upfront as dating has gotten for breeders, we're still years away from the kind of all-cards-on-the-tableness the gay community enjoys. Right now, they're basically at "This is what I look like naked and this is what I want to fuck."

The thing that makes boilersuits such an inviting party uniform is they simultaneously tell the world "I am up for whatever the night may bring," and, "I'm not really planning on taking a dump this evening."

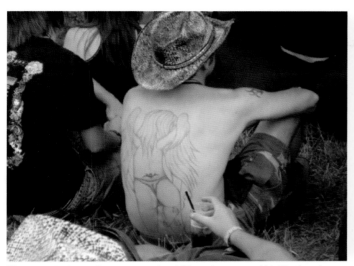

When you put a tramp stamp on a weeping child-angel on your unshirted back, you're basically taking out a restraining order against ovaries.

How furious did it make you when you'd pass that nerd whose backpack was so distended with books he had to walk at a 45-degree angle? It's like, "Look, if you want to sacrifice your chances at getting laid now for greater success down the road that's fine. But sacrificing your back is just hubris."

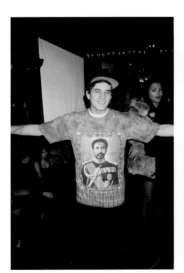

Some people think it's stupid that Rastas are allowed to smoke weed, but how else do you convince yourself that God was a guy who waited until 1942 to outlaw slavery, lost his country to the Italians, and let 50,000 of his subjects starve to death before being deposed and buried under a toilet?

I never thought I'd find myself sticking up for sweatpants and stretched-out Bugs Bunny shirts, but at least they made us feel bad when the other kids on the bus pried off your filthy running shoes and tossed them out the emergency exit (and you got in trouble for it).

I wonder how often homos in Italy try to use a "straight panic" defense after beating up the Gucci boot-boy they went home with only to discover he just wanted to sit on the couch and coke out over Sebastien Tellier 12-inches.

Can you imagine what a letdown it is for people who set their time machines to 2012 expecting this to be the future?

Putting on BET after a couple of bong rips can be eye-opening, but it comes nowhere near to the levels of culture shock you get from taking a pair of stoned Indian kids to Becky's BBW Burlesque Basement.

Being a nerd in Hollywood must be weird, because even if you make it to the point where you're running the show, you still have to deal with the fact that it's not really your party.

This goes out to all the high school sex martyrs who forewent years of screwing anybody they want in order to stay with that one boyfriend who's a couple years older and knows a lot about swords. God knows how many school shootings your vaginas have averted.

Hey art school, why the long neck?

Phew. For a second there I thought the next generation of northern Europeans wasn't going to be a bunch of coddled, sanctimonious man-children who all do graphic design and only stop talking about how stupid Americans are for driving cars to complain about the quality of the beer you just handed them. Thanks again, art dad!

People like to bitch about the third-worldification of the West and how we're all doomed to jobless penury, but to be perfectly honest I'm looking forward to it. At least the Filipino junk-mobile aspect.

After working its magic on poor English people, ska fans, racists, anti-racists, and Slade, skinhead has finally gotten around to tidying up the Western world's last bastion of aesthetic antipathy: lesbian intellectuals.

Hey, aren't these the same two drunken saps in charge of guarding the Communist border in every funny Cold War movie ever made? How are they still cops? They must be the world's greatest beneficiaries of Germany's failure to appreciate the comic timing of Harold Ramis.

The only way to win at Drunk Guy Jenga if you're the Drunk Guy is to pass out so hard that your buddies have to drag you outside after the bar closes and call in sick in order to keep playing.

This girl looks like she was grafted together from every prepubescent boner I got at swim practice, PE class, and midnight screenings of my mom's copy of Cher Fitness.

It just isn't a night in Ibiza until Teddy's made the rounds.

Not sure whether this is a crustie wearing the pelt of the bridge-and-tunnel douche he just curbed or a former stockbroker who just went off the deep end but color my pants brown either way.

Cock-blocking isn't cool, but if witnessing a scene like this doesn't tap into some vestigial "Save the queen" instinct and make you want to do a full-body leap across the table to get his clammy little penis-fingers off of her, you might want to check your chromosomes.

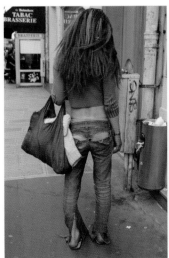

Why's everybody making a big deal out of Winkers all of a sudden? French ex-model junkies have been on that shit for years.

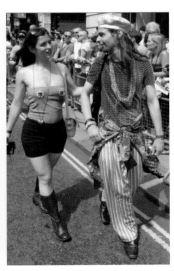

Is this a Rik Mayall side-project we missed out on, or did someone actually consent to fuck a living tribute to their nanna's neckwear?

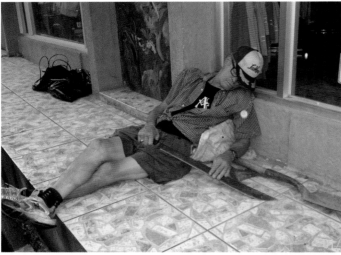

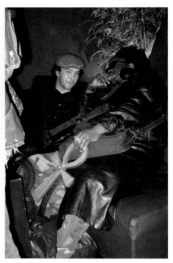

You can tell the old hood is getting rough when you can't even leave an old shovel out on the porch without some dickhead kid trying to run off with it.

"All these goth bitches with the ankhs around their necks are poseurs. Check the papyrus—those niggas carried that shit."

Has there ever been a better facial model than David Yow? Maybe it's just the result of 20 years' Pavlovian conditioning, but something about that mug just screams funny guy who can handle his drugs and has a lot of funny stories about prostitutes. It also goes well with stains.

Remember that promise you made to yourself at 15 never to let anything stop you from rocking. That's not a question. We're saying, "You need to remember that shit and stop welching out all the time."

Not sure how you feel, but polite-looking girls in cardigans and high-waisted skirts induce such monstrous thoughts in me I'm starting to worry that I spent a previous life as a granny rapist.

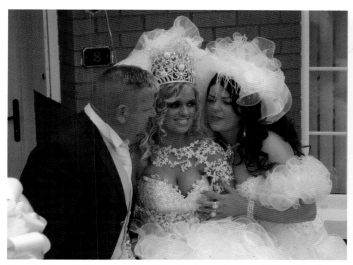

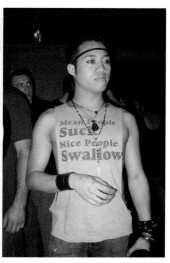

I've got no clue what homos are planning to do with marriage once they've gotten the go-ahead, but considering the tan-creamed, Malibu-Barbie tumor we've let it become, they've got their work cut out for them.

Going to Erasure concerts is really weird if you're not gay or asian.

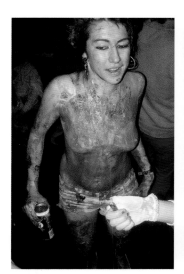

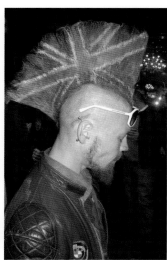

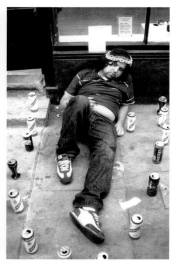

The first thing you learn in Color Theory is the second you mix blue and green, it's over.

You know 500 years from now some ass-hole is going to think this is what people in the 20th century looked like. It's like how we take the entire middle ages and go, "Oh yeah, they were a bunch of dick-head knights."

Wow, you don't see most people's corpses at their wall memorial. Usually it's just some flowers and those candles with saints on the side and maybe a mural of them on the bike that killed them.

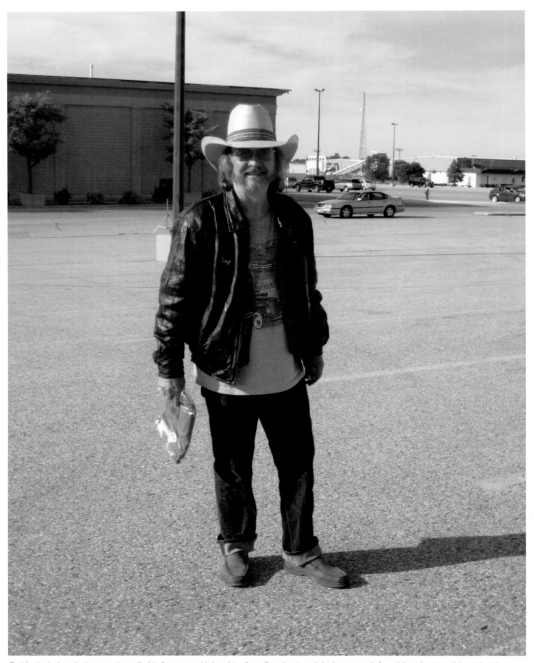

Ex-hippie dad sucks because he calls his four-year-old daughter "man" and gets weird when you ask for advice about anything other than music. Regular dad sucks because he thinks "ass" is a swear and has the same three jokes on permanent rotation. In-between dad raises such perfect, marryable children he turns everyone into a drooling Jewish Yenta.

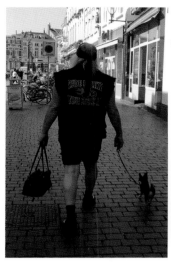

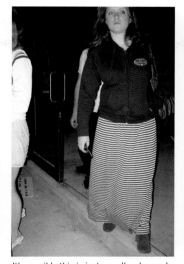

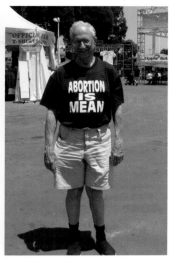

"Goddammit Eloise, *Oh, just let me get a picture with that biker holding the monkey skull. It'll be cute. What's the worst that can happen?* Lord only knows what that brute is doing with my body right now. Where the hell is this Chinese antiques store?"

It's possible this is just a really advanced breed of party-stripper whose schtick is showing up looking for her little brother who was supposed to check in with mom over two hours ago and then all of a sudden the skirt's flying off and *Jock Jams* is blaring and tits are everywhere.

I know you think this is just another reductivist fundie with no real grasp on the issue, but if we accept the fact that "Mean People Suck" then by the Transitive Property of Stupid People's T-Shirts it follows that "Abortions Suck," which is exactly how they do them.

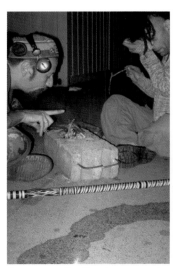

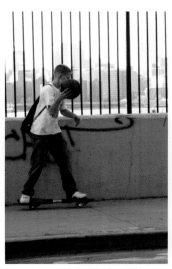

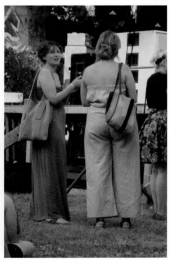

Come on, guys. Even if you have managed to stone your brains back to the Pleistocene you could still brain a guy with that devil stick and take his lighter. This is just ridiculous. What are you planning to do for dinner, delicately carve a single bean?

I don't know if it's the blending of kids' and teenagers' ideas of "cool" or some pheromone the balls release right before they drop, but there's just something about 12-year-old boys where everything they do makes me so angry it feels like I'm about to grow horns.

Someone told me these pant-tops were supposed to be a throwback to Cher's TV outfits in the 70s, which is weird because I don't remember the episode where Sonny made her be the back half of the hippo.

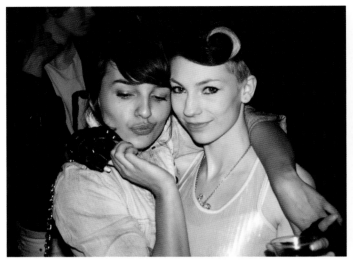

I vote that we replace room full of blondes with these two for "every teenage boy's fantasy." It's more realistic and it acknowledges just how many of us were jerking off to *Tank Girl* and *Love and Rockets*.

If you ever wake up at the back of some wharf with your head ringing and the sound of chickens coming from somewhere, just talk to my man Yurgos here. He's a totally stand-up guy and will help you out of your fix with minimal sodomizing.

Muslim girls get a bad rap because so many of them come from countries where they can get their tongues cut out for mouthing the word "sex," but if you hung out with some Tuareg chicks, they'd teach you to tear the roof off the proverbial motherfucker.

If American kids are really serious about bringing back skinhead they need to spend a little less time arguing about Harringtons versus bombers and just focus on getting down the basics.

Doesn't she remind you of that Just-So Story, "How the Leopard Got Her Ass Eaten Out for over an Hour"?

This is the epitome of "the best night of my life" in the "pregnant to a coke dealer by 18" community.

Meanwhile, the direct marketers of the world still look like they made their mom drop them off around the corner.

She's SMS-ing her friend to say that she's "gone all out with the Stevie Nicks vibe tonight" but what she's neglected to include is that even in her elongated "bubble perm and tranq addiction" period, Stevie never ever looked as tragic as this.

Did he purposely rip those jeans himself or were they torn during the stampede to get into the auditions for the Berlin leg of Mr Annoying Little Media Queer 2009?

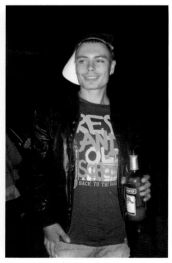

When girls tell their parents they met a nice Spanish guy on their European vacation, dads don't think of Javier Bardem. They see this.

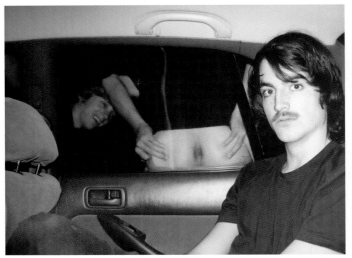

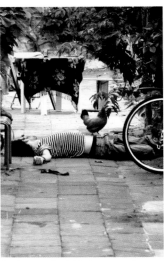

It's hard to call out your friends on their bullshit without it seeming like a joke, but if one of them is turning into a serious, self-important asshole it's vital to figure out a way to slip him the news.

Getting completely blackout wasted every weekend isn't so great for your liver, but it does turn Sunday mornings into your own personal version of *Lost*.

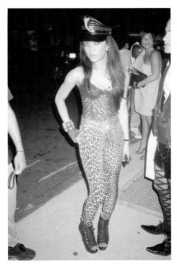

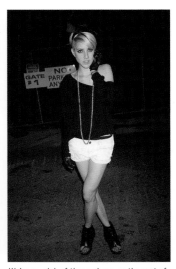

Pulling off the Apollonia is one of the most daring fashion feats you can ever embark upon, because if even one detail is a pubic centimeter off, you end up as a fascist mannequin for Frederick's of Dollywood.

Jail is for losers and people who don't know how to bargain.

We're as sick of these shoes as the rest of the thinking world, but doesn't she have an early Madonna as Minnie Mouse thing that makes spats-with-shorts sort of make a lot of sense?

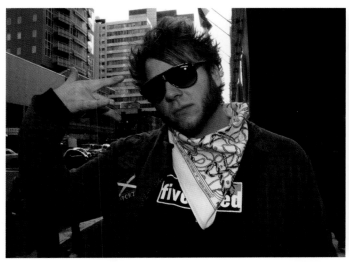 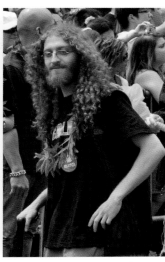

Trying to picture the kind of father responsible for this 40-year-old, trade-show X-Man is like a 21st-century Zen koan, only instead of enlightened you just get really, really angry.

The problem with saying that marijuana doesn't lead to violent impulses is that it only applies to the people who smoke it.

They're fighting for a world where annoying first-year-at-college know-it-alls can wear popsicle boxes as hats without me wanting to beat them to death even though they're a girl.

Whoa whoa whoa whoa whoa, whoa. Not trying to tell you what you can and can't do with that face, but maybe you should leave the tricycling through the red-light district in a raincoat to someone a shade less creepy. Right now you're making my ass clench so hard I'm worried my next dump will be glass.

"It's actually awesome that Aunt Ruth kicked me out of the house 'cause now I get to wear whatever I want, whenever I want."

After suffering at the hands of store-bought Kurt & Courtneys, Sid & Nancys, and Siegfried & Roys for years, we've finally decided the only acceptable Halloween costumes for couples are those British kids from the *Goo* cover, two back ends of a horse, or going as each other.

I don't care if it's a reconnaissance mission on that old guy's dog pen across the crik or just foraging the couch cushions for spent Oreos, whatever this afternoon's adventure is, I'm in.

Waiting out your girlfriend's straight-edge phase is so nerve-racking it's like trying to get to sleep the night before Sexmas.

How hard would it be to have a bad trip around these two? You could get off a train in Nazi Germany and they'd be like, "Yeah, it kind of sucks here, but we know a couple spots." I bet they even smell laid-back.

Remember all those shitty jobs where you had to wear some stained-up work shirt that came down to your knees and how hard you'd try to cool up the periphery in case you saw anybody you knew? I wonder if that's why punk and goth girls cram so much shit on their necks and arms.

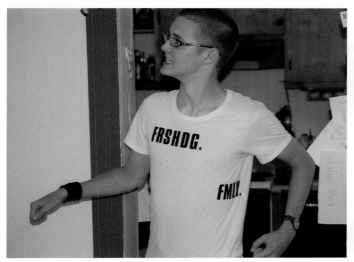

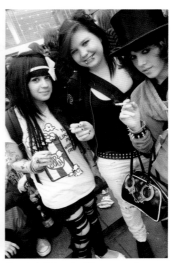

He's everybody you ever wanted to punch, positioned in exactly the position you want him to be in when you punch him. You'd knock off his glasses and bounce his head off the side of the refrigerator and he'd hit the floor and look up at you all hurt and confused with a perfect trickle of blood coming from his nose. He's punching-people porno. In fact, I'm jerking off right now.

New dads take note. When you work away from home too much and raise your kids on birthday magicians, cartoons, and MTV emo hour you will come home one day to this and start yelling "Sarah, I can't even recognize Kylie anymore!"

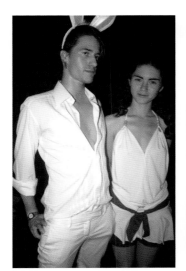

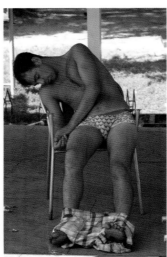

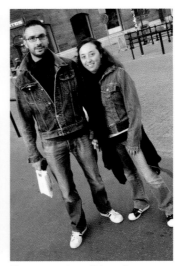

Quit pretending to be weird. You've got perfect genes and your parents are richer than God. You should be lounging around a castle on a mountaintop and generally getting the fuck out of anywhere we hang out.

The class-war people should ditch the posters of Bush with a target on his head and have this party chief passed out at a music-conference barbecue instead.

They can repeat any dialogue from any DVD box set ever released in the history of sitting on the couch and merging disgustingly into the same sweaty delivery pizza sweating, cat litter stinking, eight years into this and still no kids, crazed relationship of a catastrophe of disappointment.

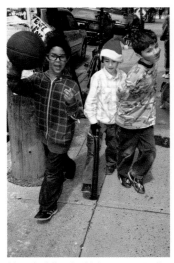

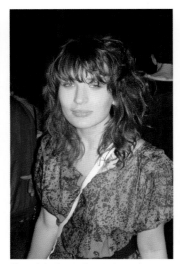

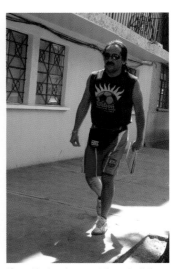

I love the folks who think you can actually fill kids' brains with a bunch of stuff about respecting cultural differences and avoiding stereotypes, as if the second they're out the door they aren't all playing basketball-rappers and Santa-Jedis at Abu Ghraib.

The only bad part of capturing a sleepy-eyed supertigress like this in the wild is trying to think up some bullshit to write about her shirt.

If anything's going to cut through all the divisive bullshit with immigration and bring us all together it's not going be some corny political slogan or a song or even a chain of restaurants. It's got to be something profound and universal. Like embarrassing dads.

Look, it's been a long week. If you need me I'll be down at the park having a couple Buds with Professor Barnabus P. Galaxicon and his Splendiferous Brain-O-Scope.

I'd marry him or her, but only if they were playing the Ramones version of "Baby I Love You" while I walked down the aisle with him or her. I wouldn't even bother asking which it is. That's genitalist.

I've never wanted to be reincarnated as a gross piece of sticky brown stuff on a chair until now.

This either belongs to a Young Adult author whose work combines ghost stories with military technothrillers or a rich, Mediterranean man-child whose DNA combines four or five Y chromosomes with the gene for being really fucking stupid.

Not sure if baggy pants, neck-concealing scarves, or a tall, lanky friend are the best accessories for a guy of your stature. Right now your buddy looks like he's saying, "Look dude, I just want to say I'm sorry about dropping that anvil on you in front of Lisa. We cool?"

Without bringing a bunch of writing or props into it, three shorts and no shirt is probably the easiest way to dress up as the opposite of a brain surgeon.

If you're a psychotic murderer who needs to dispose of body parts across town, dressing up as a *Godspell* unicycle mime on his way to work is a surprisingly good option. The unicycle case will fit the average-size kid and people tend to assume the smell is just coming from you.

Finding a hippie girl who keeps her bush in check and whose farts smell like jasmine sounds like a dream come true, but you've got no idea what a pain it is trying to get her out of the house.

Used to be a dad like this would have the kid in therapy at age 10. These days divorce and addiction in the family are so common that kids are just like: "Meh, fuck this loser. Who wants to go spend what I just stole from his wallet?"

I have a feeling that if this was the guy who came to fix the office computers we'd never have that problem with the fucking email ever again.

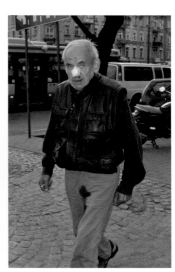

I hate all these boring remakes of *Friday the 13th* and *Halloween*. What if they remade *Hellraiser*, *Conan the Destroyer*, and *Cruising* into the same movie? That would fucking rule!

Thank God there's somebody out there who's fighting the racist and stereotypical view that the only people who cannibalize children these days are warlords from Liberia.

It takes years of practice to pull "street-fighting alcoholic old guy" with dignity but he's nailed it, right down to his freshly peed pants.

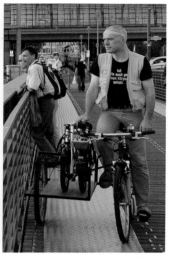

Who the fuck are these women? Who the fuck cares! And if the shots these photographers sell for a few dollars apiece to shitty websites with huge readerships never got taken, would anybody hear the cries of their children going hungry? Probably not.

OK, just so we're clear, you used a bike wheel to make a sidecar for your bike so you can carry a tiny, folded-up bike with you when you bike. Is this what happens when Germans take acid or just the world's most elaborate variation of "My girlfriend lives in Canada"?

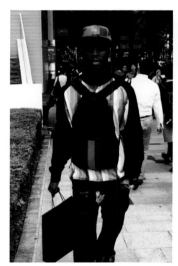

You've got to be out of your mind to commit suicide by tiger.

So you Junior Mengeles weren't content with your cockapoos and beagadors and pugadoodles and now you've graduated to full-on monstrosities like giant two-mouthed pit bulls and sideways husky-terriers. Disgusting. At least Dr. Moreau had the decency to keep his abominations on an island.

I wish I could tell you whether or not this Venice Beach Robocop's legs were going "*kzzzzzzt kzzzzzzt kzzzzzzt kzzzzzzt*" with each step, but it was hard to hear over the sound of my mouth going "*Haaaaa Haaaa Haaaa Haaaa.*"

Yelling shit from cars is primarily for drunken jocks and other people who haven't gotten over high school but you've got to admit that it's extremely easy and feels guiltily satisfying when you screech away. It's more or less the beating-off-to-Bangbus of insults.

Now that Ryanair is making transatlantic flights it's going to be interesting to see how far the Deltas and Virgin Atlantics of this world are gonna go to keep their customers.

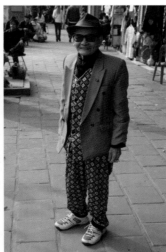

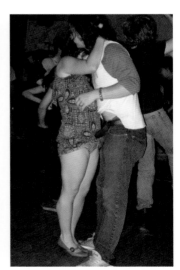

It's about time the Natural History Museum's tit-makers started taking their cues from back issues of Cheri. That said, let's all pray to God they found a more recent source for the crotches.

Everybody's got their dicks in a knot about Chinese bootleggers and how they're ruining our movies but I think they did a pretty good job with *"Oh God!"*

You know boning a girl is the right decision when even God's like, "What the fuck are you waiting for, my help? Get in there!"

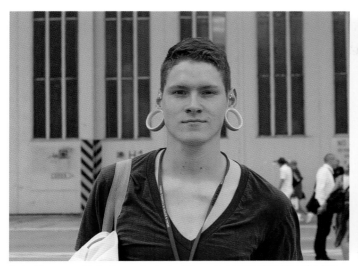

Look at how smug this fucking genius is about the worst mistake of his life so far. Just how much TV did his dad not let him watch?

The LSD-S&M-toilet-brush-from-*Sesame-Street* vibe is surprisingly big in East London these days.

Fuck this faker. A real goth would be at home eating licorice ice cream and reading about Rozz Williams on the internet; certainly not high-fiving at the *New Moon* after-party.

On the whole, do you think society is becoming more or less sensitive to the profoundly mentally ill now that a lot of their care providers are in the private sector?

Chemical castration for pedophiles, yeah, yeah, whatever. Can we please start talking about what the punishment will be for the people who went to see *I Hope They Serve Beer in Hell* instead?

Something about the combination of muscular skinhead thug and delicately flavored rabbit tagliatelle in a beautiful back garden in Rome is making me ask myself that age-old question again: Am I a fag?

These guys remind me of what vikings would have been like if they were slightly more courteous and also dressed like gaylords.

With all the talk about scat bars and puke porn and octopus sex it's easy to forget that Japan also caters to totally reasonable fetishes, like guys who wish girls walked around without pants all day.

You wouldn't believe the kind of crazy shit we've been getting into every night since we became friends with Robbie. We're just worried someone's going to hit him in the head again and set everything back to normal.

If that sexball let me put my freckly hands all over her person I'd be doing dances with her that make Skerrit Bwoy look like a tree sloth who hates sex, not getting into staring problems with every other guy in the room. But I guess heavy hangs the face that wears the tits.

Homos are at the very forefront of experimental fashion research which means when something goes wrong, it's a CERN-level disaster.

Wow, guys. You really pulled out all the stops on this piece, eh? I bet they call themselves something like Ralph & Stephan and will be the favorite catamites of the bottom-rung gallery circuit until their metabolisms slow down in a couple years.

One of the easiest ways to distract people from the fact that you're an aging trance aficionado who won't shut up about the Thai full moon party you went to 15 years ago is to make your face look like a gnome scrotum.

Nice New Balances, Morgan Merman. You were one pair of kelp-bedraggled fins away from selling us on the Atlantean earth-raver lifestyle but you just had to support your widdle arches.

If you just got to a new country and have no clue what they consider "cool" DO NOT ask the other immigrants' kids for help. In case you've forgotten, you guys are all in the same boat.

Any old asshole can fingerpaint "wisdom" and "good action" (?) on their sleeves, but few have what it takes to step out into the public sphere and bring those words to life.

I would give anything to hear what this conversation between a womyn's-literary-group president and Vicious D. Slim Rock is all about. How much they both love pussy?

Who knew all it took to become the world's best friend was an undershirt, some markers, and a little dose of Radical Honesty?

Hoping you never bump into her again for the rest of your life isn't a great feeling, but the six hours of completely insane contortionist fucking at her weird apartment with three cats is going to be pretty memorable.

Grad school types and religious assholes want us to believe that assimilation is always painful and racist and a forced betrayal of immigrants' cultural roots, but what if someone's just psyched to live in a place that isn't an abject shithole?

Taking in an exchange student seems like a bad decision when he walks in on you in the bathroom or wants to learn about baseball. But what about the part when you teach him that it's customary to present your host with a 10-inch swath from the bottom of each garment at a party?

Who knew all it took to become the entire female world's worst nightmare was an undershirt, one of those iron-on thingies you put in your printer, and a little dose of Radical Honesty?

The only thing worse than making your kids dress cool is trying to out-cool them.

Might be time to call it a night when people keep asking why you're dressed up as a drowning victim.

Who needs a family or kids or friends or a career or goals or shoes or sex or a working relationship with your parents when you've got your weekly coffee dates with Reg? He'll keep you up to speed on what's cool these days and how the entire rest of the world has got it wrong (not you).

If I was his mom I could probably deal with the fanny pack and the stereogram hobby and even the living in my basement and not picking up his jizz-encrusted underwear part, but those socks would send me into "Where did I go wrong, oh Lord?" overdrive.

I guess it's OK to jauntily perch atop an old lady's bike if you look like the French Dennis Wilson. (I want that jacket.)

Carrying your own is a great way to save on money and trips to the bar, plus guys like it cause it's like an hourglass for when they're getting laid.

"Eating out of the palm of your hand" is fine if you like to gamble, but "Taking notes on everything you've said all evening" is when you really know you've got this one in the bag.

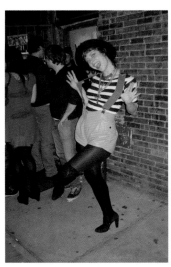
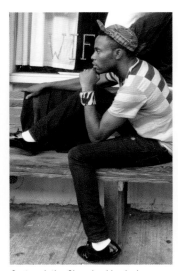
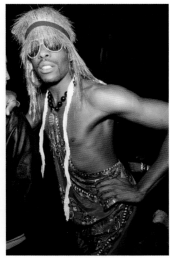

"Wearing the rubber shorts" is the polite way to refer to massive female horniness.

Contemplative Ghanaian bicycle dancers may not be representative of much of the earth's population, but I still think this is the guy we should send to meet the aliens. It's a good look for us.

Sure, Rick James hair and sunglasses is an obvious choice if you're going for black, pansexual party guy, but did you also come up with color-coordinated finger braces? Or using Nanna's dish towel as a peek-a-boo dashiki? Didn't think so.

What, you think taking a picture is going to shame that fucking slob into cleaning out the freezer like he said he was going to do four months ago? Look, if half this shit isn't scraped out and covering Mark's bed by the time I get back, it's going on yours, Rosie.

Wow, I don't think I've ever seen anyone fail this miserably at jean skirt, high-heels, and low-cut shirt. She's either got to be some covert-ops feminist provocateur or an autistic nerd who read a book on how to be a hot girl.

Can you believe American girls are just now getting into yamanba?

Yeah, yeah, Asia is so weird and kooky, but you realize this is basically what Chinese people see whenever they pass some white kid in a Free Tibet shirt?

Holyfuckingshit, I swear I will never do drugs again in my life. I won't even drink coffee. Just please, please quit materializing like that every time someone offers me a bump.

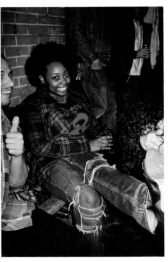

Eight-hole boots with no socks make most guys think of Fairuza Balk in *American History X*, that's why you need the gold pyramid studs to take it out of National Vanguard territory and over to somewhere a little classier like *Desperately Seeking Susan*.

While white girls have an arsenal of sweatpants and sneakers weeks deep and each more stainy and menstrual than the first, this is as comfy as it gets in the black community.

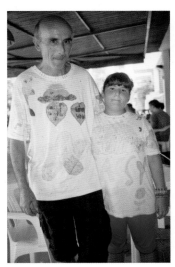

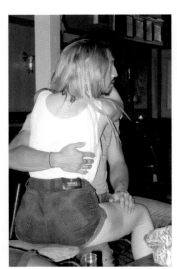

You can whine about how Baby Boomers and hippies ruined the world, but how else would we have grandpas who fully indulge your preteen outsider-art fashion collective?

Thigh bruises, druggy after-hours clubs, and high-end buttshorts come together in a little-used mental place called "I wonder if I could take him if I used the element of surprise."

American Culture gets so shit on and blamed for and yelled at and griped of you have no idea how nice it is to see someone who just wants to be its friend.

Twenty-five years ago AC/DC fans had facial tattoos and 15-year-old girlfriends. These days they're balding branch managers and the only time their shitty wives let them go out is when they give them six months' advance notice.

Not sure why Italians are so cheesed off about *Jersey Shore*, cause the orange line of the Long Island Rail Road makes that shit look like the fucking *Bicycle Thief*.

This is the uniform for crap party promoters all over Europe. If you see one at a crap party, tell them you're one of the crap sponsors or the crap organization the crap party is being thrown for and he'll give you free crap drugs.

Dressing like a naive ginger turtle in a new city is only a good idea if you're actually trying to find out how to get to "the fuck away from me."

Oh yeah, that reminds me, would you rather be a closeted Albanian "performance dancer" who learned English from episodes of *Highlander* or a supervillain whose power is nobody can look at him without barfing?

Pet rats are for skate witches and homeless crusties on St. Marks Place. If you want to show the world you're a fun-loving guy with an endearing nurturative side, you've got to climb up the evolutionary ladder to party mouse or even tuco-tuco.

Am I losing my mind, or did this aging Lagwagoneer find a way to take standard LA douchewear into some sort of weird, alternative Brooks Brothers territory? It's like a skate-punk version of breaking out the Nantucket reds.

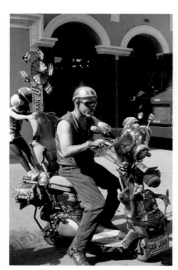

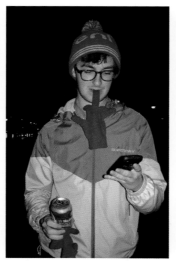

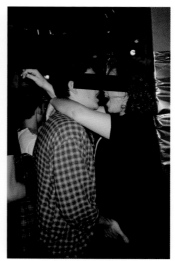

Dads clinging to the subcultures of their youth are usually too depressing for words, but we're going to grant a major exception for Puerto Rican garbage-mods.

Quiet nerds who are into their jobs and keep everything neat and together seem like they're missing out when you're in the middle of your drunken shithead years, but they're really so far ahead of the curve it'll be years before you realize how hard you've been shined.

You know what I predict? Ten years from now making out in public will look as antiquated as "necking." The future belongs to the fingerbang.

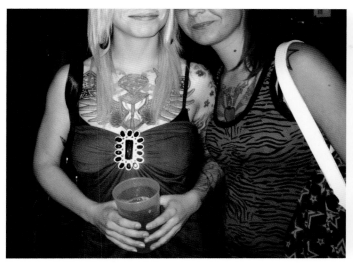

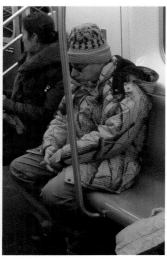

For all the crimes against Japanese culture that US tattoo artists have committed, Europe still takes it for turning one of the most banal phrases in the English language into a bootleg Journey logo that looks like a highlighter gave her a Cleveland Steamer.

Kind of weird how something designed to keep you from being a target for gunmen in the woods has the opposite effect in the city.

This is the type of girl who will walk around downtown with no shoes on, give homeless dudes long-winded explanations why she can't spare any change, get her camera stolen, step on a nail, and still have a dumb Canadian grin on her mug.

This is what I imagine every person under 25 will look like in the year 2018, and I want no part of it. Being tragically hip and androgynous with a well-conditioned emo haircut and *Star Trek* glasses is awful like getting punched in the dick.

If being a middle-aged man who looks like a lesbian dental hygienist with skin that looks like a vintage leather jacket is a good look, then this guy is ON FIRE.

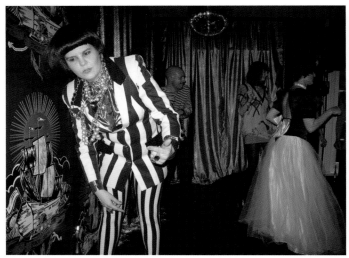

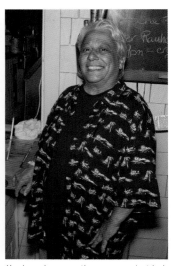

Remember in high school when you thought this is what your wedding was going to look like? That was a weird phase.

You know how sometimes you can just look at a dude and instantly tell what an amazing lay he is? Same goes for owning the city's reader-voted "hottest wings joint" 15 years and running.

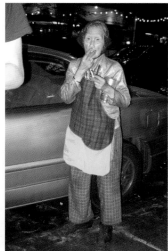

No matter how big of a wasted fuckup you turn into, nothing will ever top the pure shameless obliteration of your early teens. I think it's the mixture of not knowing the difference between a beer and a full glass of vodka and the fact that your only reference drunks are cartoon characters.

If you've ever done meth for more than four days, you may recognize this clashy, multi-plaided lady as the thing that keeps appearing in the corner of your eye while you're talking to your friends. Seems like a bad vibe at first, but if you're nice to her she'll help you slay the tree-demons.

If there's one thing the 2010's clears out, I hope it's all the fake nostalgia for "e'ers gone by" and wearing ratty compilation outfits that make you look like a time-traveling street urchin. Let's make this the decade humans finally start dressing our age.

Quilted jackets are for women who hate their own asses, crimping your hair is for white girls who wish they were "ethnic," bell bottoms are for people who think their lives would be better if they'd been born in the past, and purple, of course, is the royal color of the sexually frustrated. So basically you're a walking billboard of your own self-loathing AND you look like shit. Nice one.

The art of seduction is based on making subtle metaphors alluding to sexual intercourse. If that fails, whack her on the ass with a plank of wood like your dick's on fire and you're trying to put out the fire.

Nobody's really done it right since bullies in the 50s, but how awesome would it be to have a sidekick who dressed like a less fancy version of you?

Not exactly a great look for bar-hopping, but what if he went to bed every night at 8 and only called when you were hungover and he knew about some art installation where the room smells like bread? I could get behind that.

Isn't it weird how these undercut Nitzer Ebb/Dementia Precox girls crop up every 20 or so years then fade back into the woodwork? They're like a comet you regret not fucking.

As America's tramp-stamp quotient continues to rise unabated, the quest for unsullied backs is getting more and more desperate.

If you're six-foot-ten and you find yourself at a daytime rave dressed as a giant alien with mascara running down your face, it may finally be time to stop listening to your unconditionally supportive friends and family and seriously consider taking your own life.

What do you like more: his toned body, his very reasonably sized package, or his feather duster? Oh, or his studded leather outfit you might find hidden deep in your dad's closet with a spiral notebook that has "I hate fags" written over and over on every page? There is no right answer.

It is easier for a giant asshole to enter the eye of a needle than it is for punk Ted Bundy to get any further with her than feverishly sniffing her face.

This guy is a total toss-up in terms of what he does with his life. He's either a crystal-meth addict who works part-time at a place called Smoothie Hut or he's a kid who went to your high school who is now the #12-ranked Razor-scooter rider in America and gets flown around the world getting rich off his stoner college hobby. Either way I wouldn't let him have protected sex with my sister.

Somehow you stumble upon the MySpace page of these guys' band, the genre is "Electro/screamo/emo/punk/pop," and they have songs about having text sex with chicks. They also have gigs booked from now until next year and are 17 years old, while you have no health insurance.

These are the guys who have the audacity to take their shirts off in the middle of the nightclub, mouth the lyrics to a Rihanna song to each other, drink cranberry vodkas and make incredibly heavy eye contact, then call some guy a faggot for wearing leather pants and throw a drink directly at his face. You have to respect their heterosexual-homoerotic circus—it has no laws.

It's not totally clear whether this Armenian immigrant who walks around selling belts realizes that he is on the cutting edge of fashion, but either way I applaud him. He should have DVDs for sale stuffed in his mouth.

This is what is commonly known as "Living the Dream." He's the guy your mom gets weird about because they dated briefly in college and you secretly wish he was your dad because he grows his own weed, listens to Hall & Oates, and uses the term "fingerblasted."

Seeing a girl who looks like a sprite that came out of a magical forest filled with other moderately hip chicks makes my little Jewish dick very hard. If her bicycle had a basket filled with fresh vegetables and a Gary Shteyngart novel I could legitimately achieve an orgasm to this.

This is the guy you meet in some dumpy beach town who knows everybody and can get you great seafood salad or help you find coke. If he ever moved to the city he'd end up on a food line, but in this crappy seaside hamlet he is the goddamn mayor. Also, if you squint he looks like a MILF.

Jesus, Lou. I know it's the beach and you're tired and who cares and whatever, but couldn't you choose a slightly more dignified manner of repose? You look like someone just felled a giant.

Growing up with a lot of brothers is a pretty good recipe for a girl, but you can't push the feminine influence all the way down to zero or else you end up with this.

From the Boogie Down Bronx of the early 70s, to Berlin's experimental gay elf collectives of 2012; the world of street art never fails to make us go "wow."

You might think it's funny to see a balding 311 worshipper with misaligned plugs and a tribal elbow making attempted gang signs at a DJ party in Vienna instead of walking his girlfriend's tiny dog in San Diego, but what if he crossed with one of the native strains of asshole and went on to become some sort of hybrid superprick?

We know. It's rough. You wait all year for the South Beach Singles Slammer and right when Jeremy sidles up to you with a pair of appletinis that little fucking troll and her idiot sister dawdle out of the woodwork to ruin everything as usual. Let it out, Beth. This was YOUR day.

Cartoonist and devoted Stern fan Johnny Ryan was the first non-Vice person to guest-write the DOs & DON'Ts *since Joe Strummer in 1999.*

This woman can see your future, and your future is having your balls glued to a 747 that's flying into an 80-story disco.

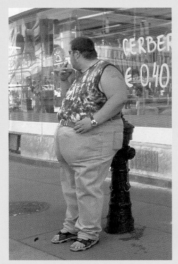

This guy makes me want to deep-fry my Jimi Hendrix records and play them on a turntable made out of mashed potatoes and baked beans.

If you knocked an ice-cream cone out of this guy's hand he'd pick it up off the ground and eat it just to spite you.

When you're 250 lbs of pure muscle you can dress like a total asshole and get away with it. It's in the Asshole Constitution. Look it up.

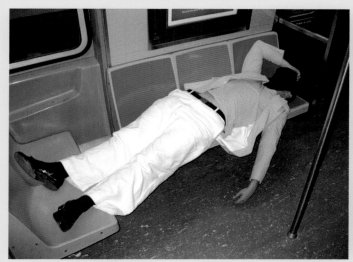

There's a tired old lady carrying two heavy bags full of groceries who wrote this guy's name in her little fuck-you book.

When a gay guy is checking you out you know you're hot. When a straight guy who dresses gay is checking you out it makes you want to feed your eyeballs to a badger.

The 10th annual Hot Testicle Awareness Week came and went and still no one noticed.

When I was a kid I bought a pair of rubber monster hands. I ruled Halloween from '78 to '81.

Whoever is at the bottom of this cliff is about to be crushed by a jazzalanche.

These new hybrid cars run on electricity and pussy gas.

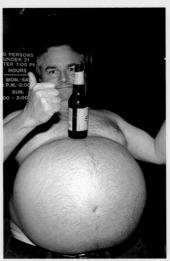

Just before Neil Armstrong got back into his spacecraft, he chugged a beer, threw the bottle into a crater, and said, "Moon, you da man!"

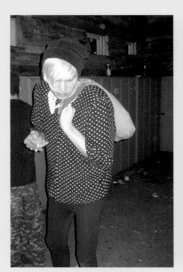

Running away from home is adorable at any age.

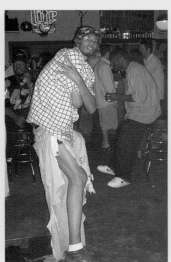

You feed your jeans to your rottweiler, the rottweiler shits them out, then you wash the jeans and wear them. You look like a laid-back jam master and the dog's digestive system is kept busy for 20 minutes. Everyone wins.

Guys really like women in high heels because it looks like thumbs coming out of the heels of their feet. High heels tap into man's primitive unconscious, where he still dreams of fucking females with prehensile feet.

Girls, if you want to fuck a ghost put on some harlequin tights and Dolly Parton's Coat-of-Many-Colors and jam a bunch of crazy shoelaces in your hair. Ghosts pop major boners for that shit.

First, Matrixing in Japan, then Lethal Weaponing in Australia, followed by Die Harding in Los Angeles…

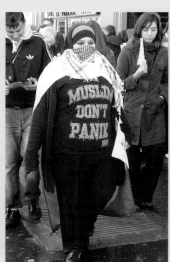

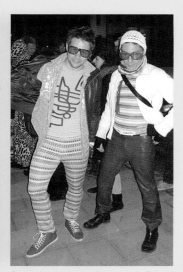

When you take your shirt off in public and then neatly tuck it into your pants you're saying partying's cool, but minding your manners is cooler.

Mohamed Atta actually wore this same shirt on 9/11 and unfortunately everyone believed it. America learned a tough lesson that day. T-shirts lie.

Remember that scene in the movie *Twister* when the tornado touched down right in the middle of the douchebag factory and sprayed hot, unhomogenized douche all over the countryside?

dos & don'ts

For Vice's 15th anniversary we published a "lost" issue of the magazine from 1994. So all the DOs & DON'Ts were pictures from the early 90s with eerily prescient captions from 15 years ago and the design and fonts were all ripped from places like The Face. Sorry, explaining it kind of kills the joke. Maybe forget you read this.

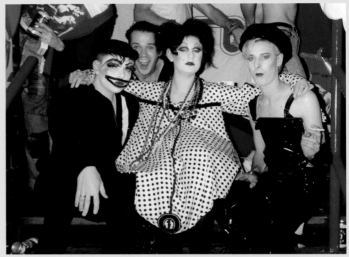

Club kids kill me. Their leader guy Michael Alig is like a Charles Manson for the mid-90s, only without the murder.

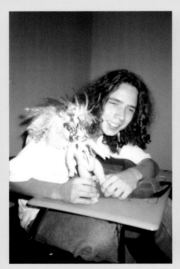

If something ever happens to our national acid supply, homeroom is really going to suck.

It's hard to go wrong with rockabilly. The accessories are subdued and not tacky, the rules haven't changed for 40 years, and you hardly ever run into any fat ones.

We love these East Village tweakers who broadcast public-access TV shows from their mother's living room in Alphabet City. They are the real New York, and the neighborhood would suck without them.

How would you rather spend eternity: listening to Doors fans sob over the alcoholic loser you got buried next to or continually pushing a rock up a hill only to have it roll back down at the top EVERY FUCKING TIME. We'll take the boulder.

When did CBGB get taken over by roided-out rock 'n' roll tourists? It's become like Extreme Planet Hollywood, or like some rich asshole started a fake New York in Las Vegas.

Man. How embarrassing are white people?

When Seth doesn't pull off his aggressive BMX tricks correctly, his crew boss makes him eat a whole jar of peanut butter with his hands. It's called doing a Puck.

She's aiming at "grunge goes to college" but it's coming off more like the cover artwork of a porno VHS where schoolgirls have to drink the jizz of hairy Germans out of a martini glass.

dos & don'ts

Rave sucks, but when you're stuck in there, tripping your balls off, catching sight of this and becoming so transfixed with it that you start developing religious theories about asses, it actually starts to make perfect sense.

If Chris Cornell looked like this I'd start listening to Soundgarden again.

A preppy wearing short shorts and boat shoes is like a needle of goodness in a haystack of awful grunge turds wearing cargo shorts with eight-hole Doc Martens with daisies painted on the toe.

This girl's real actual name is Angel Butts.

Going to Europe and seeing people under 30 who don't look like they're wearing drugstore GG Allin costumes is such an ocular relief it's like shooting valium into your eyes.

I don't know about exploring the inner workings of the universe with E. The first couple of hours can be great but how about the last three hours of lying in bed a day later with the fear, frantically trying to jerk off to lessen the pain?

What does a guy keep in a bag like that? Twenty-three loose dildos? A box of cunts?

So far the only funny thing Jerry Seinfeld has done is convince an entire generation of unmarried uncles that it's perfectly acceptable to dress like a member of a New Edition tribute band made up of guys on their first day out of rehab.

Keeping the shaved head but losing the septum ring and surface piercings and connector chains and filthy camo shirt with Discharge patches holding together the shoulder leaves you looking like you just got back from concentration camp.

Put a knife in this Sheep on Drugs mad scientist's hand and he's reading my mind as to what I'm doing as I creep up behind him on the dance floor.

This is the Fat Jew's first set, from back when we thought he needed to be set apart from the general "us" so that people wouldn't conflate our senses of humor. Yeesh. Us sometimes, right?

If you sit in this car for more than three minutes, you will all of a sudden be wearing a formfitting Armani Exchange t-shirt, have a cell-phone holster on your belt and a severe case of homophobia, and smell like Drakkar Noir. Seriously, it's like magic.

This is the type of Austrian couple who listen to drum 'n' bass, dress like they're pimps on Halloween, and are so sexually liberated that it's uncomfortable. They'll approach you and your girlfriend at a coffee shop about having a foursome and totally not be offended if you're not into it.

I don't know if it's the slightly lazy eye or what, but he is freaking me out. He looks like he'd rip your throat out, swallow it, and then say "Don't ever disrespect me again" to you IN YOUR OWN VOICE. I wish he was my uncle, and by uncle I mean longtime family friend who seems like he'd try to fuck your mom if your dad died.

She's quite fit, which is always a good look, hangs out at American Apparel, and has a great tan. This girl is basically a freshman at NYU who makes a terrible drunken mistake the first week of school and spends the next four years with a nickname like "Skidmark" or "Puketits." Except she's eight.

Looking like you just came from an anime convention used to be amazing until it became boring. It would be a lot more shocking and awesome if they were wearing sensible Rockport walking sneakers and nonwrinkle khakis.

I understand it's Yom Kippur, but there are better ways of atoning for your sins, and I'm pretty sure it doesn't count when you enjoy it.

If Annie Lennox banged a caveman and they had a child and it learned how to dress by watching the 1995 cyber-thriller *Hackers*, it would look exactly like this confused European blemish on the forehead of humanity.

You're 17, have cheekbones like Jared Leto, and can get an erection on command. Wait until you're 27, cocaine has assassinated your boner, and you're living in a one-bedroom with a girlfriend you resent and hate sleeping with so much you masturbate while she's in the shower. Then you can cry, you little bitch.

Nothing says "I made my selection from a laminated poster on the wall of a tattoo parlor at Daytona Beach Spring Break '99" quite like a fading, half-eaten strawberry dribbling off your ass.

Sam McPheeters guest-edited a special Anti-Music issue of Vice *in which all the* DOs & DON'Ts *were his Men's Recovery Project bandmate Joe Preston, also of Thrones, the Melvins, Earth, High on Fire, etc.. Commenters on the website got really pissed at seeing his mug for an entire month (which made it all the sweeter).*

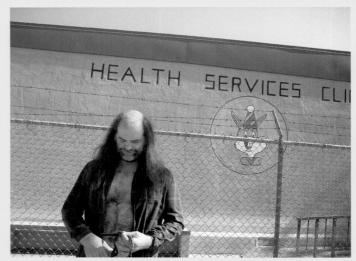

Despite what the hair-gel industry wants you to believe, making yourself attractive to the opposite sex is a simple matter of playing up your secondary sex characteristics. For women this means keeping the body hair trim, the hair-hair long, and wearing something that draws attention to your round parts. For men, going completely bald the day you turn 30, never shaving anywhere ever, and losing your temper over something inconsequential roughly once a month. See? Simple.

With everybody dressing like they're in a Martha's Vineyard dinner production of *H.M.S. Pinafore* all of a sudden, it's nice to see someone holding down the greasy, working side of the boat. (Aft.)

Two of the most common mistakes people make with beards are clipping down the neck like the dad from *Family Ties* and giving a shit about any other aspect of your appearance whatsoever.

Now that Claire's sells razor necklaces and motherfucking Polo puts skulls and crossbones on little girls' tennis skirts, punks need a new accoutrement to remind the world that we're a wild pack of rabid manimals who can't be tamed by society's laws. The werewolves already have dibs on tails, so I guess that leaves us with this.

Babysitting money is some pretty good scratch, but hanging around playgrounds dressed like an aging Serbian war criminal might not be the best way to find new clients.

Can we please cool it with the fucking baseball hat and sports jacket? It's 2010 already. We should be taking our cues from William Gibson and Gary Numan, not some movie where Billy Crystal's scared of being an adult.

Taking a book to the shitter is a nice, discrete way to warn bystanders of the unholy terror you're about to unleash, but carrying a coat hanger to perform a third-trimester abortion on your bowels is so far past TMI it's basically a Whitehouse lyric.

The wistful, "emotional toll of the road" parking-lot photo-op works a lot better when you're a trio of moody, flat-stomached 20-somethings in B&W and also not burning an eyehole in the neighboring porno shop.

When you think of all the accumulative decades of coolness and strife and gradual progress it's taken just to bring us here, it's pretty hard not to agree we're looking at the apogee of human achievement.

Getting your posse to the perfect equilibrium of straight man versus goofball versus ravenous, slobbering food-ape with visible stink lines is one of the trickiest balancing acts in friendship. Why do you think the Three Stooges went through so many Curlys?

Few women will admit how primally attracted they are to Bluto (either one) because a) it's weird, and b) doing so would open the floodgates on a slob revival that would threaten the very basis of the sex-for-basic-decency exchange.

It doesn't matter which button you push, just push *something* before the sexual tension causes a power failure.

Mike Watt pioneered this look where you dress like a suburban dad mowing the lawn and just add one slightly-off element like aviators or an Econochrist patch. It's been the saving grace of slightly husky punks for the past 30 years.

Reading challenging books at college get-togethers is a one-way ticket to Gash Central Station.

While most of us have dedicated half our brainspace to juggling a religion's worth of ethical dietary restrictions with the conversion rate of two-thirds of a banana to hours on the elliptical, it's easy to forget that there's an entire segment of our population still struggling with "Try not to eat an entire bowl of mayonnaise."

Must be weird having your chief natural predator be stoned guys who decided to go to the Chinese grocery.

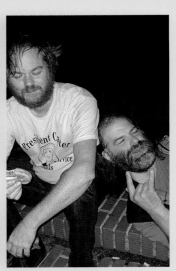

How many times have we got to say this? You either give up the band or you don't go bald. If anybody wanted to watch a wrinkly, unkempt penis noodling aimlessly for hours on end they would have just taken up that guy in accounting on the Jeff Beck tickets.

Touring is a great way to find out what it'd be like to go on a family vacation where everyone in the car is your pissed-off dad.

Nice fucking vest, dude.

Rob Delaney wrote these for us after doing a comedy set in New York that was mostly one long description of the horrible car crash he was in back when he drank and the torturous recovery process. He is the only person we are OK with Twitter making famous.

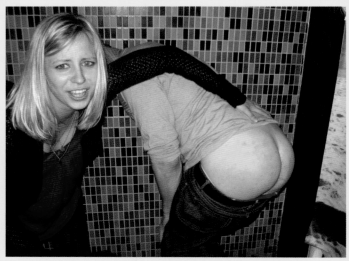

Ain't a party without a little strawberry shortcake for dessert! The store was closed though, so we're gonna take turns eating Peter's splotchy ass instead. Ashley's got dibs on the first bite!

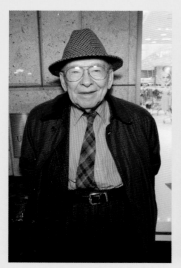

Yukking it up looking at your little fashion photos? Well, have at it, whippersnapper, he's been mowing pussy in this outfit since before your daddy dodged the draft.

If your shit hangs low, you might as well rock pure ass because seeing people's underpants is just as horrible.

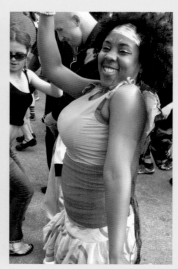

The sun is hot, the ocean's got all kinds of fish in it, and you, young lady, are a motherfucking delight. My mom and I want to get to know you.

Jan, Nancy, and Terri are excited to share 3,000 words about tulips with you! (After they sync their slide shows to some provocative Sting jamz!)

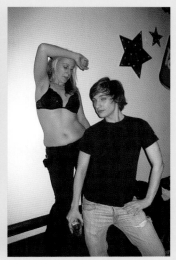

Gina, you are not picking up what Brendan is putting down. And what he's putting down is "I taste men's penises after furniture class!"

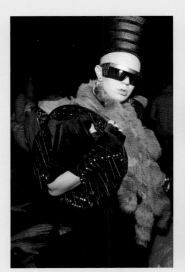

Before entering the club, everyone had to sign a waiver, acknowledging that they were "at peace" with being fucked to death by Dr. Alexander Criscofist.

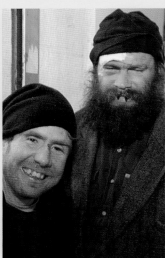

Now and then, Rick Rubin has to go deep undercover to sign a new act. Here he is trying to land "Futon Phil," whose mixtape of him vomiting blood over Deltron 3030 is some NEXT-LEVEL SHIT.

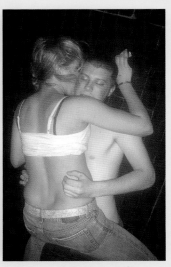

Rather than ejaculating in you, Shawn the human sperm just wriggles up your little yum-yum and turns into the worst baby since your stepbrother Aaron.

Hey Jacques, wanna talk me out of this body sock and rock me with your pasty cock until 6 o'clock?

Nothing beats a look that says, "Physically I may be in Cincinnati, but my spirit will always be in 1985 Berlin!"

The coolest thing about this guy is that his awesome wife is exactly his age. He's not rocking May–December style; his shit is straight winter round the clock, and that's hot.

Who likes red triangles? *(Everyone in the whole world raises their hands.)* This pretty little thing is paying it forward, with interest.

I hope our friendship lasts 75 years, Maurice, but if you die before me, I'm turning you into a body pillow!
xoxo,
Rob

After a tough day of babysitting, we Yonkers gals like to shake it free at Houlihan's!

I'm art that you can fuck! But I'm a little nervous because this is the first time I've been in a building made of wood since 2004. Educate me with your gaijin dong!

Cee-Lo fucked Webster on a cruise last summer and now their baby, Sprinklewagon, is dating Chelsea Handler.

Fresh from the scene of a multiple pediatric butt-murder, Reggie the Clown wants to make you a balloon gazelle!

What's going on, Ricky Kravitz-Navarro? Hope you don't get in a car accident tonight!

Not only is that tattoo the exact opposite of a tramp stamp, this girl is the exact opposite of everything the tramp stamp stands for. She's like some avenging angel who stepped out of a Springsteen lyric to take back the good name of American sluttiness.

Not sure if your dead buddy's memorial hood is the most appropriate place for a Pollack joke, but I guess if Lukosz can't look down from heaven and see the humor of the situation he should never have tried to force that giant pit bull behind the engine block in the first place.

Hey, don't give us that look. We're not the ones who made you dress like a teenage Wavves fan who got struck by lightning.

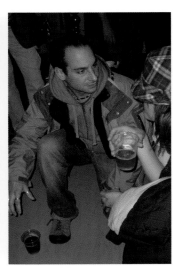

Aw, that sucks. You were just one XL Tupac shirt away from hitting the shitty, extremely misguided ethnic role-models trifecta.

OK, I know you've got some elaborate justification worked out about "standards of beauty" and how this would look totally normal to the Uighurs of Western China, but do you have any idea how fucking bored those wiggers get out there?

Whoa dude. I know everyone from *Redbook* to Mystery stresses the importance of eye contact, but if you don't throw a couple blinks into that 1,000-yard hypnostare she's going to start thinking you dosed the wrong drink.

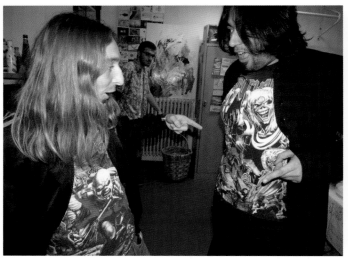

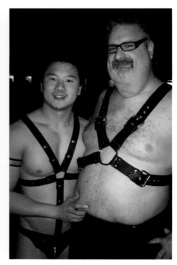

Being excited about Maiden is a no-brainer, but being excited about people being excited about Maiden is so adorable it makes us want to take you guys to Build-a-Bear.

It sucks when folks insist that homos are normal people. Like you'd rather be Craig and Glen our accountants than a pair of caustic partymonsters who have exponentially more fun than everyone they grew up with? On the other hand, we are totally into Craig and Glen being homos.

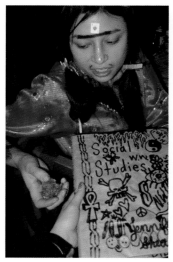

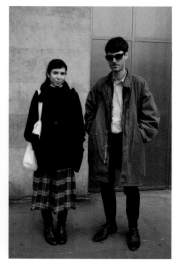

The rules get a little more involved once you start closing in on the marriage zone, but for grades 7 to 17, if you want to make a boy interested in checking out your crotch, your mantra should be "Keep putting weird crap all over my face."

I never really got that thing from 1950s TV where they'd have ladies' legs coming out of a box of cigarettes or whatever until I saw the punk version and was like, "Wow, you're right. There really could be a can of beans up there for all I care."

How great are modish couples who know exactly where to stop before hitting cartoon territory? You could make a video of these two talking about records and sell it as friendship porn.

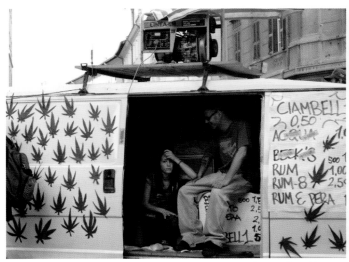

Remember how free you felt when you told your parents you were going traveling with Stefano and you didn't care what they thought about him? How free do you feel now Valerie?

Isn't it weird that anytime a meathead/frat-boy-type character who wears football jerseys and Jägermeister keychain necklaces tries to be funny or zany, he always ends up looking like a cartoon rapist from outer space?

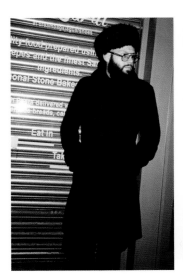

Guy, I know you see yourself as a nihilistic Russian intellectual with progressive views about gender, but all the rest of us see are greenish-black cloud shapes forming in the corners of our eyes from the laughter cutting off our oxygen.

Hey, look at that, he's wearing the official boring-guy-at-the-party uniform. I wonder if he's got any opinions about the legalization of weed.

"In case you're wondering Kathleen, I brought you here for a reason. There's something I need to explain and it's not going to be easy."

Most public monuments are to people who kill lots of people in a war. When you see one with a pig pile of friendly gay men gently pinching each other's bumbums, it takes your mind off how much the world is going to hell for a few seconds. More please!

Is there anything sadder than people who are actually ashamed about their sexual hangups? It's 2012, people! If there's anything we should have learned from the homos by now, it's to be loud and proud about the things that make you want to scream jizz out of your peeholes.

Does anybody fall off the wagon harder more gloriously than old straightedge kids? London even has a weekly party called Crucial Thursdays dedicated to them where everybody gets hammered listening to Judge and Integrity.

You know you're in trouble when a girl in a t-shirt and sweater turns you into a spastic Jerry Lewis who says things like "Did you go to school around here?" and "Let me get a picture of you and your plate." Try to imagine the level of retarded shit that'd be coming out of your mouth if you could see the top of her tits.

It's going to be pretty weird in 10 years when Michael Jackson's kids are past the grieving stage and finally want to party.

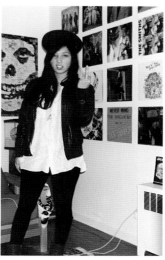

Ninety percent of the time a white guy with dreads will look like an asshole 100 percent of the time, and 60 percent of the time redheads act creepy 99 percent of the time, which makes this guy a total and complete nightmare numbers-wise.

Fuck me? No, actually, fuck you. You bought an entire dorm room at Urban Outfitters.

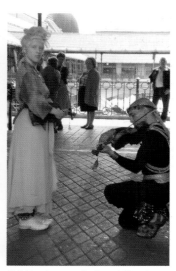

Oh jeez, will you look at that. You mis-matched your chinchillan clog-toppers *again*. I tell you, Claire, if you could just lock down the small stuff, I bet all the other pieces of the childless 35-year-old media professional puzzle would just fall into place.

I had no idea how exhausting making me eternally grateful for my genes and early upbringing was.

Watching too many foreign art films is really really bad for the shoes.

If a black roller-skating genie who fights crime in his urban neighborhood by means of roller-skate dance-fighting wasn't a failed sitcom pilot at some point in the 1970s, I would honestly be shocked.

I've been there, brother—the deep pit of shame. Like the time I found out I had a UTI, then got upsettingly drunk and slept with a girl who looked like Drew Carey, then woke up and realized I'd missed my dentist's appointment. Congratulations, you are now a grown man.

This is what I imagine everyone in Europe between 18 and 28 looks like: slightly androgynous, zany but in a manageable way, extremely positive, and on their way to hang a futuristic-looking lamp somewhere. I don't know how someone was able to take a picture inside my brain, but I'm into it.

Yes, this is funny. Don't be a nerd.

This is how things used to be in the olden days, when a man would get disgustingly drunk and pass out in a pile of trash butt-naked but still have the decency to hang his hat over his genitals. It's nice to see the next generation carrying on the time-less traditions that make America great.

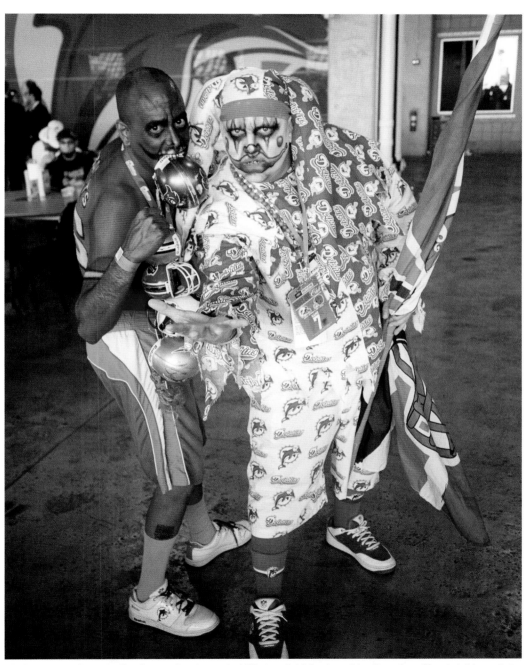

Big Fan may seem depressing if you've never been to an actual NFL game, but it barely scratches the surface of how dark things get at most stadia. There are levels of dadlessness that will literally haunt your dreams.

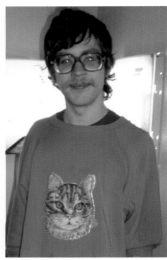

This kind of thing starts with neck kissing, progresses to the reach-around tit grab, then builds up to her getting fingered over her jeans for 20 to 25 minutes to the point where the denim is chafing my hands and her breath on my neck is... Wait, what were we just talking about?

This girl looks like a mystical creature who would rise from the water during spring break, try to seduce you with a goblet of banana daiquiri and attempt to 69 with you against your will, and then scamper away on all fours. Think *Lord of the Rings: Daytona Beach.*

Having an "old soul" will never hold a candle to having an "old stache."

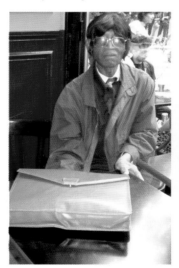

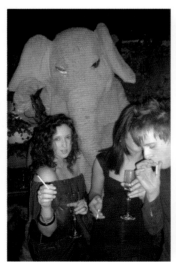

What's the point of being ethnically "other" if you can't rub that otherness all up in white society's face? There's a reason everyone loves loud-ass black girls with Angela Davis hair and it goes extra-double for Indian Beatle-mummies who practice tax law.

Dude, if you think any of your bullshit "moves" are going to make her leave him for you, you're drunker than you think.

Spring is great and it's nice not to be cooped up indoors, but there's something to be said for shitty weather and the camaraderie, strange bedfellows, and can-do spirit of partying it engenders. It's like boredom is everyone's common enemy.

I love how freaked out and amazed about themselves jocks get when they do boring stupid shit like shave their head when they're drunk. In ten years time they'll be high-fiving about this moment over a couple of backyard brews while their fat, sad wives push their kids around in huge fucking strollers the size of a tank.

Nothing gets you laid like a permanent drawing of an AIDS victim on your arm.

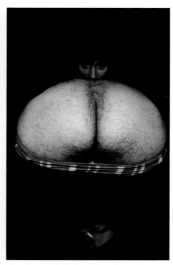

He sees a twist on the Scissor Sisters guy. We see an out-of-work car salesman having a brutal nervous breakdown in public.

By the look of his face, I'd bet his wedding ring's gotten quite used to sitting in that little pocket in the front of his jeans.

If you're worried about that tiny mole on your chin that seems to be getting bigger you need to go and get that shit checked out ASAP.

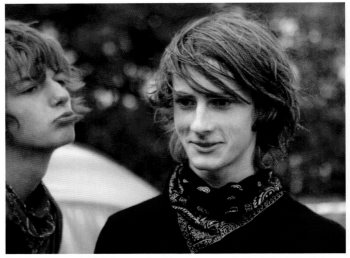

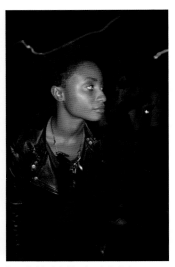

Yeah I want to punch his little pouty friend too, but are you digging Withnail Van Halen here? He's such an exquisite blend of American and British partymutts I don't know whether to disavow the Declaration of Independence or my heterosexuality. Try picturing him twirling a drumstick (like everywhere he goes).

I wanted to brighten her hair, but every time we fuck with the levels on a picture online commenters accuse us of photo-shopping it together from two different sources. Which implies that we spend about 2 million times more time caring about this bullshit than they do.

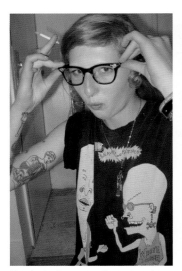

If you're too hung up on the septum pierc-ing or tatts to see her for the lifelong riff partner she could be, you deserve whatev-er humorless, cosmo-drinking normal you end up with.

Wow, this is exactly how husky *Rocky Horror* fans and gangly anime girls with bad posture picture themselves: A laid-back weirdo couple you bump into in the middle of the night and invite you over to smoke opium and watch old Strawberry Switchblade videos on VHS.

Fact: 99% of all eye-attention is paid to the top third of the body. Wasting your time on the rest is as dumb as playing the lottery.

Dirty Dancing may have taught us all the virtue of getting off in a vintage Chevy, but the "with another person" part is pretty crucial to the equation.

I don't know whose bright idea it was to turn my 8th-grade backpack into people, but I'd really appreciate the expired condoms, cigarette lighter, and ripped-out pages of *Hustler* back, thank you.

Sam McPheeters was right about punks and goths looking too clean these days. It's like being in a *Twilight Zone* episode where the narcs won and didn't realize it.

What is it with guys who spend their free time improving their ability to kick people's asses and dressing like five-year-old short-order cooks whose moms think they're "bad to the bone"? Oh right, it's they like to get into fights.

Why do security guards always take such a hard-line stance on being awesome?

I know this is like the third time we've had a Hummer in this book, but have you ever driven one? It is like spraying yourself in liquid "Fight Me" and streaking a gym-monkey symposium. I don't like being the one to say this, but slapping a cheetah collar on its bumper and taking it to Denmark may actually be punk.

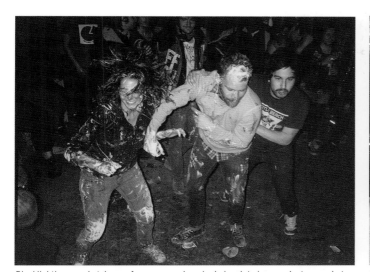

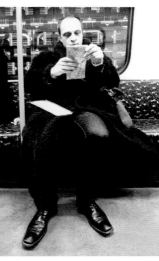

Blacklighting your hotel room for semen and vaginal ejaculate is a prudent move, but do all of us a favor and keep that shit away from the dance floor. We honestly don't want to know.

I thought we were all pretty clear on the Addams Family being a comedic thing, but apparently that part didn't translate so great into German.

Good call hiring Frankenstein's dead-eyed, football-hooligan grandson to lumber around the mall grunting your store's name through the PA. What's on sale this week, toddler nightmares?

Take it easy An-Yoon. We all know grinding is ejaculation's most dangerous game, but if you guys set the sexual bar any lower, you're going to start losing girls to the Islamists.

Yeah, that's what girls are into, thinking about sharp metal objects going into their cunts.

You know you've finally hit your stride when you can look back on the hateful nonsense you let yourself get consumed by in your teens and laugh about all the pussy it cost you.

East Asian culture is resolutely a gut culture. Doesn't matter if you're the president of Baoshan Iron & Steel or a motorbike courier who doesn't mind the rain, you ain't nobody until you've got a big enough paunch to tuck your shirt into the top of when it gets hot out.

I know you think adopting third-world orphans is a rich-shithead move, but you try shaking those little guys loose and tell me which feels worse.

Whoa, this guy is like when Snapple or whoever introduces a new holiday flavor and every sip makes you alternate between, "This is the most delicious thing I've ever tasted in my life," and "Please, please don't let them discontinue Easter Skins."

Fur is still murder, but at least when dweeby Asian girls do it it's by awwww-wwwverdose.

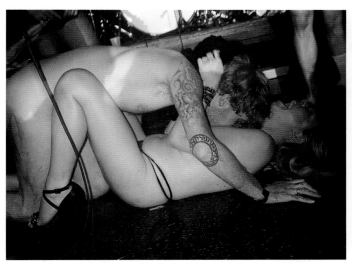

This one's for the Suspicious Samuel in the top right corner. A barfloor orgy is supposed to be about trust (especially when it's of the impromptu quick-the-owner-is-in-the-can variety) and stuffing your wallet into your gym sock puts everyone on edge worse than those creeps who wear ski masks.

This must be what wiggers look like to black people. An embarrassing, half-assed accumulation of all their race's worst elements. Cousin Becky is basically the Flava Flav of whiteface.

What is it about nice weather and white people where they grow a melon-sized tumor blocking part of the brain that governs basic human decency? LA has some pockets of intelligence that make you think "maybe I'm wrong," then you go to Australia and it's like their entire culture's been on Spring Break since 1788.

I don't care if you shoplifted that from Abbaworld, there's no way in hell a shopping basket counts as crust punk. Can't you weave together some old GISM patches and dreads into something to carry your sundries in? At the very least an assflap bindle.

Someone needs to teach all those Europeans bitching about American entertainment and "ze Disneyfication of ze arts" that people who stand on a sidewalk and guffaw while their drunken countrymen pretend to shove balloon dicks up their asses shouldn't throw stones.

Being Matt Pike playing in Sleep is about the only way for a man to score an 11/10 on your DO test.

I kind of like it when girls get really mad at stuff; especially when they look like new wave Myra Hindley.

Take that, Westboro Baptist Church! Heaven DOES accept fags.

Taking as many drugs as you can fit in your body and putting your dick in as wide a variety of girls as possible may seem like the most pressing use of your energy right now, and it is, but keep in mind that 40 years from now what you'll remember most are the capers, so make time for Muttley.

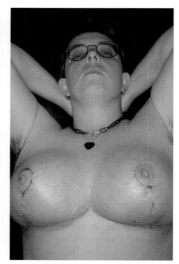

This is what the IT guy at your office wears under his casual-Friday "No, I can't fix your computer today" t-shirt. Yes, Tim, I agree that the last Staind record was underrated.

I know we always stress the context of outfits and how you can't be a stoic Matrix assassin in line at the Jamba Juice, but come on, guy, even waiting on a snowy bullet-train platform for the Keymaker or whoever you still look like somebody who's only been blown by a computer.

If you knew how much this mook was being paid to hang out outside all day, operate a bunch of fun-as-shit machinery, and make passing women feel uncomfortable, your MA in Labor Studies would shit itself.

My senior photography thesis this year is entitled, simply, "No fucking shit."

Watching a guy so homophobic he turned his torso into a giant testicle paw at his borderline-transexual girlfriend fills me with such delicious irony I probably ought to take out Giggle Insurance.

Don't you start making excuses for him like "Maybe the light was out in the mud room" or "Maybe he stepped in a puddle on the way back from the gym." Look at that face. He knows what he's done.

Credit where it's due: Making yourself look like someone photoshopped stupid clothes over your normal outfit is the most effective DON'Toflauge we've seen since being a naked guy with an ugly dick.

There are many things in the world more terrifying than a group of ethnic children who live in a country torn apart by war and dictatorships who by age 16 will be leading rebel guerrilla-army factions and ripping out the hearts of government soldiers and eating them raw. Actually, no, there are not.

A soothing pastel lady bathed in sunshine and offering you half a McRibwich can only mean one of two things. You either went home with a certified Hangover Helper or you overdid it way worse than you think last night.

Youth in Revolt was nice of Hollywood and all, but punctuating a picture-perfect Dan Clowes getup with a gasp-inducing rack is the most heartfelt shoutout to the nerd community we've seen since the invention of web porn.

TV perpetuates the myth that gangs of cool kids always keep a nerd around to help out with homework and weird math situations because it's written by nerds who wished gangs of cool kids they grew up with kept them around to help out with homework and weird math situations.

People who worry about what tattoos will look like when they're old are exactly why we like people with old tattoos in the first place.

I was sad because I had no shoes, then I saw a guy who had folded two pot-leaf-emblazoned pieces of attic insulation over his feet and tied them with Scotch tape and I was like, "Wait, what the fuck is going on with that guy?"

Kiss that fucking beer like it's your best friend and one of the only things in life that will never ever let you down. It is one of life's only truths.

The best thing for a girl to wear to brunch is whatever you had on the night before.

This guy's Hitler mustache and affinity for parakeets are both terrifying and fascinating. Something tells me he was a fringe invite to his own wedding.

After centuries of growing up under the most oppressive, shame-inducing parents since God, Asians have finally forced the pendulum so deep into cool mom we're starting to go, "Take it easy, Liz. The kid's 0.3."

When most people call someone "ahead of their time," they're usually thinking in terms of years or decades. Rarely geologic eras.

Take a look out there, pardner. There's a whole world that's waiting to be lassoed, dragged off to the reservation, and forced to make shitty leather fedoras for men whose relationship with their children is strained and emotionally taxing for anybody who has to listen to him talk about it (which is anybody period).

I've heard about this. Grimace-skin coats. Baby grimaces are hunted and beaten with clubs and then stripped of their skin. The skin is made into coats that are packed inside Happy Meals and sold only at McDonalds restaurants in Beverly Hills and Dubai. Sick.

Ooh la la! This looks like the perfect place to buy your tuxedo once Phish are inducted into the Rock and Roll Hall of Dogshit.

Guys, I had no idea *Little Britain* was an actual documentary series about real human beings in England. I thought the whole thing was a comedy show. I am so, so sorry for laughing at all those poor, sad, brain-damaged wretches.

The URL says it all. If you want to barf, or if you want a crazy night (which will probably involve a lot more barf), then this dude will hook you up.

The best way for girls to do smart is to just do stupid really really really stupidly.

I don't know who told girls that klutziness was a dealbreaker, but he must have had a real pickle up his ass about both of you laughing until your faces are sore and against each other's.

How fast do you think that tubby loud-mouth in the Yankees hat and basketball shorts would shut his fat, goatee'd mouth about "real New Yorkers" if this trio sauntered in from their afternoon bocce?

Remember how good you thought you looked before the world told you your hair was dumb, you have girl wrists, your nose is weird, playing in mud is for jam fans, you're a shitty writer, and you have gum on your collarbone? You should work on getting that confidence back. It was cute.

Sending your daughter into the world with a bowl of free bacon is a surefire way to put her on the road to either greatness or a severely protracted abduction.

Keep this photo by your toilet for the next time you're having a hard time making yourself throw up after partying for too long . Concentrate on the lower left of the image and in no time your ringpiece will be exiting your body via your mouthhole.

This is the type of photo that your dad sees of you when he's medium drunk and mutters, "I can't believe you came out of my balls."

Being at Bonnaroo with your buddy from college and seeing endless bands with names like the Ghost Shepherds and Origami Radicals and possibly getting hepatitis C from walking around shoeless in a pile of cantaloupe rinds sounds like an awful weekend. I made those band names up. They would suck.

The poor rich loner who heard about skating off the internet is off to the spot for the first time to be mocked to within an inch of his little helmet.

When you're so drunk you're wearing a synthetic Hawaiian lei and your breath smells like sour cranberry vodka and even this guy won't make out with you, it's time to reassess your life.

We're glad that the Fashion Industry gave homos sanctuary during the shitty 50s and 60s years, but do you ever wonder what it would be like if they hadn't, and how much more of this there might be?

Shoveling snow off the steps of your parents' house is about as metal as two dolphins jumping over a rainbow and tongue-kissing. Which I guess is actually pretty metal. Whatever. Fuck this guy.

Dude's gonna be pissed when he realizes someone hit him with a white-girl ray.

Ugh, are black people still doing that plaidy wools-and-worsteds faux-nerd thing? Haven't they figured out that looking at them causes that feeling you get when you drag your fingernails the wrong way across a seatbelt, but times a person?

In America dressing like a rich twat means looking like a tanned *American Psycho* type who girls instinctively feel compelled to fuck. I guess British girls must have a corresponding damp spot for Little Lord Fauntleroys who get sent into town to pick up some groceries for Mumsy.

Don't even bother getting cleaned up to meet your new girlfriend's dad. You could be Bret Favre dressed as Audie Murphy—all he's going to see when he opens the door is a pencil-thin erection in DJwear furiously grinding his daughter (who's Renn-Goth for some reason).

This is what Destiny's Child would've been like if Beyoncé could stuff an entire human foot in her vagina instead of singing things. Remember *Dream Girls*? These are the types of girls I dream about.

It's gotten to the point where the only way to be into anarchy without coming across like a rich kid who hates his dad is to take it to a place that's teetering on the brink of actual chaos. Like literally take it to there. And also make it kind of preppy.

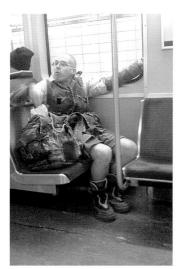

You don't need cutting-edge fashion blogs to key you into what look is in this summer, because this guy already nailed it. Rick Moranis dressed as a Nepalese Sherpa.

Though it may cast a permanent shadow over any future conversations you two can have about fucking, best friend's sister is still the sweetest taboo.

Too-rich-to-care is nice, but too-rich-to-notice-it's-fucking-90-degrees-outside-you-crazy-bitch is the way we like it.

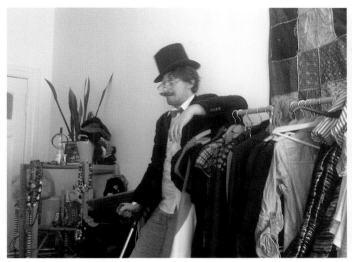

I know the old-timey aesthetic of curly mustaches and straight-razor shaving is popular with 20-somethings these days, but this is just too much. You know what would tie this moron's outfit together nicely? A cane pulling him out of the frame by his neck and a bout of scarlet fever.

Old Spanish ladies who live on 10 euros a week and reek of mothballs are far preferable to trashy, doughy 25-year-old R&B fans who have 10 credit cards and reek of JLo "Glow".

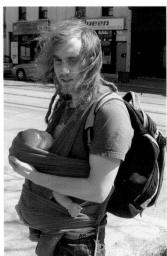

I hope my family pulls the plug before this is what I remember women as.

First of all, that better not be his kid. Secondly, don't own an earth-toned BabyBjörn and expect not to get searched at the airport, Cheech. I can smell your dank nugs from here.

"Yeah, y'know, I'm into big butts and, like, tribal piercings, and—drum 'n' bass? Yeah, I used to be pretty heavy into jungle music but then, I don't know, the scene kinda got weak after..." and here is where you walk away.

Of all things to wake up next to, this guy is definitely no big deal. At the very least you know he kept most of his clothes on, and, worst-case scenario, you could beat him up if he tried to steal anything on the way out. I would cook French toast for him and lend him money for the train.

I don't care how much goth cred it costs you, taking your mom to see Burning Spear is both a sweet gesture and a good way to help her get over the divorce.

The overall picture is a bit rough, but if you break it down into layers he's like an archeological dig of increasingly decent decisions.

American sports might be a bit more lively, and require a less herculean attention span, but give an Englishman a few sticks and a rock hard ball and it's tiny shorts in the sun for three days straight. That's the sort of grit you build an empire on.

There's no atheists in a foxhole and not a whole lot of radical feminists in a heatwave.

Can we please shut the fuck up about the "browning of America" and focus a bit on the cargoing of America? This asshole's put cargo pockets on regular, slim-fit jeans and we're supposed to be fine with that? Where does it end? Are our kids going to be walking around with teeny little pocket-flaps on the sides of their shoes and pouches of dead skin sewn onto their bare arms? Is that what you want?!

This isn't exactly what people who advocate "street medicine" have in mind, but it'd be a whole lot cooler if they did.

She's what you tell yourself backpacking through Latin America is going to be like before finally submitting to the 1,000-degree fever dream of eight-hour shits and endlessly getting hustled that is the reality.

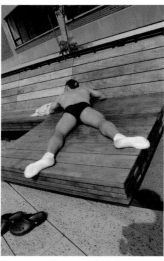

Um, not to split hairs, but what exactly did you expect to find on the roof of the Eagle? Now get in there and start chowing before we take your turn.

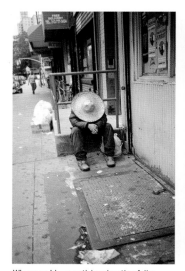

Whenever I hear anti-immigration folks pandering to Mexican stereotypes it makes me wonder how anybody could spend so much energy trying to defend America from becoming a hell of a lot more charming.

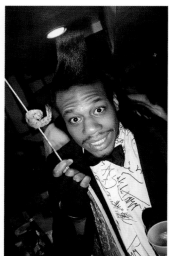

Bicycle gloves, bow ties, and posing with food are off-limits unless you're smart enough to string them all together into a New Orleans version of Oil Can Harry.

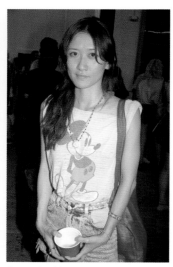

Stop saying Disney was a Nazi and coochie cutters are for sluts and the only reason guys are into Asian girls is because they're closet pedophiles—all you're doing is highlighting the whole reason people like each of those things in the first place (their shit's better than yours).

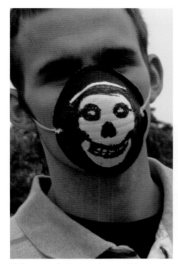

Being scared of germs is one of the least punk things in the world.

Someone needs to tell Dolce Gabarna that trying to make overalls high fashion is like putting rims on a tractor or saying you and your cousin "made love."

Hey remember that arrogant nerd from high school who wore pretentiously named hats, carried a briefcase, and was really into alternative histories of the Civil War? He's back and as pungently unlaid as ever. (New hat, though.)

The general rule of thumb is how proud you are about where you're from is inversely proportionate to how proud where you're from is about you.

I was like "Man, why's everyone at this birthday such a fucking pussy?" when suddenly Daddy Harry rolled up and gritted "Time to go, Hailey" through his teeth and all the rest of the five-year-olds were finally intimidated as shit.

Might be a good time to adjust your eating habits when your feces has a due date.

There is nothing in America that has changed more in the past 100 years than what is happening in this photo.

I usually go with gouache for portraits of my own penis, but Dieter seems to prefer the colored pencils. That's fine with me. You lose a bit of the texture on the glans, but they're much better at capturing the wispy feathering of auburn pubes he keeps so soft and clean.

I know what I said two pages ago, but I still don't understand why pedophiles can't just convert themselves to Asian chicks like this. She has the body of a 7th grader and most likely has stickers all over her cell-phone of her and her two friends in a photo booth. It's the same shit.

It's hard to tell if this guy is leading a dis-gruntled factory-worker rally for better wages or performing karaoke at one of those latino sweet 16s where the girl dresses like a princess. Either way he's got a classic mustache and is El Salvadorable.

You can tell just by how this dude smokes his cigarette that whatever it is he does artistically is so beyond what I will ever be able to understand that instead of listening to him talk it's better just to nod while quietly trying to figure out which type of Asian he is.

Not exactly sure who this is racist against but on behalf of black people, the Irish, frat boys, Fat Boys, cartoon characters, and crowd-control barriers I'd just like to say "Fuck y'all for real."

There's a reason heroin was never that big in the hip-hop community and vice versa.

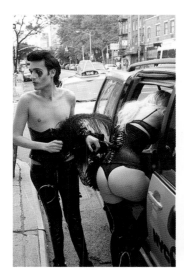

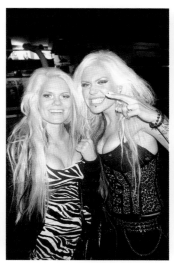

I like how most Manhattan cabbies still won't stop for Brooklyn fares or black guys under 40, but screech across five lanes of traffic to pick up hungover club kids in the kind of heat that leaves an inch-thick film of crotch sweat and body glitter when they peel their bare asses off the vinyl seating.

I don't think I've ever been as angry at tits in my life. Thanks, Belänka.

There are many uncertainties about this man, like where he came from or what he believes in. But there is one thing that is undeniably true: His pubic hair smells revolting.

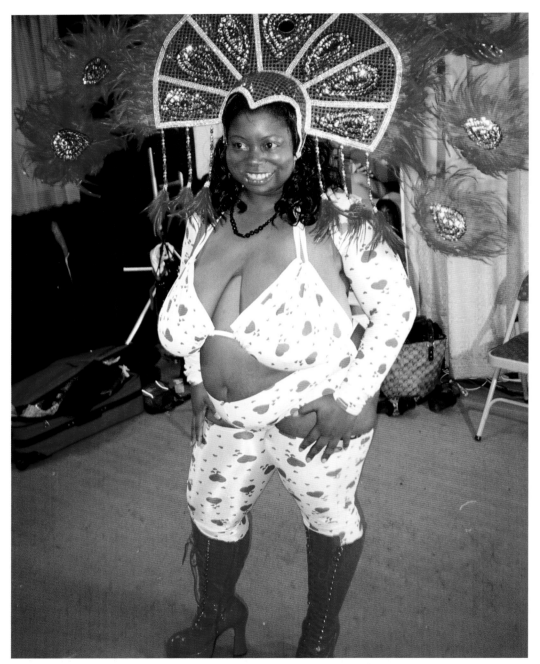

Not since Fritz the Cat has a gross old man's idea of sex shoved into a third grade boy's idea of sex made us question whether or not we're as horny as we think we are.

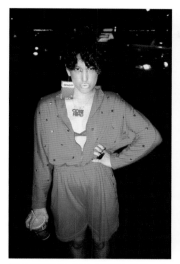

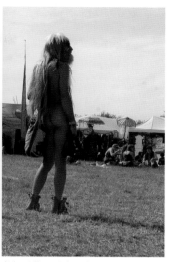

Wow, menthols, coke, and Taco Bell *and* sweatshorts? Your ass's breath must smell terrific.

Nice tag, but you left out the "-d by."

At least I'm not the only one who thought about whether Lisa Frank ever went through a weird dark 'n' horny phase like Shel Silverstein or Dr. Suess.

This errant truth teller is a great example of the fact that it's 10% what you say, 20% how you say it, and 70% whether or not what you say is accompanied by a shitty fake-titted David Mann ripoff that would get you kicked out of most Burger Kings.

Making fun of redheads always seems weird and artificial outside of Britain, but combining it with that stupid emo swoosh and the tear-streaked mascara is just asking for trouble.

This banana-yellow onesie is basically the Hitler raping a baby seal covered in spilled oil while listening to Rusted Root in a "retro" Adidas tracksuit and giving someone a fist pound and pretending it explodes on impact of outfit decisions.

NOW we're talking. Guys have finally stopped letting the world tell them that no one's interested in their hairy, sweaty, piss-stained, pungent, greasy bodies and have shucked off their inhibitions to the Beatles-esque shrieking of a million horny girls. Wait, where's everyone going?

Before hippies and Glenn Beck disciples turned it into a 50-year dumb-off, this is what protest culture was all about: Sandal-wearing "cranks" who looked like Annalee dolls and managed to be a thousand times more pleasant about accomplishing the same amount of jackshit.

So this is what natural selection looks like.

Unflattering, yes, but wearing one of those diapers that look like jeans is a great way of conserving our planet's resource of vintage Levis.

Finally, someone with the right credentials for those fucking hats.

This is why you shouldn't go around telling people things like "the world is your oyster." That's exactly the type of intoxicating optimism that leads to your band getting kicked out of the Renaissance Fair for showing up with bongo drums and not having a ride home.

Uh oh, the Tropical Nana Commando Squad found out we were talking shit about them. Does someone have a basement we can hide out in so they don't smother us under 30 yards of breezy black linen while we sleep? This is extremely serious.

"And this concludes the second annual regrettable Myspace-era tattoo support group. You all did great. Stay strong."

Hard to believe someone who could make his body so perfectly represent the totem pole of late-80s middle-school bullying would occupy that pole's lowest rung. Wait, no it isn't.

It's great you get to fuck off to the beach while the rest of us are sitting in front of a computer all day, Sal, but rubbing it in our faces on your way back is about as classy as black socks and basketball shorts.

If Caribbean men are going to act like dealing with girls on their period is the worst thing since slavery, some of us are more than happy to pick up the slack.

Redheaded bitches can be a lot to handle (especially when they're on some weird crystal-magic-meets-Lisa-Frank trip) but if you can put up with a little extra bush and about twice the period bullshit of normal girls, there's a whole world of filthy, dick-bending sex in it for you.

We've bitched for years about people treating the city like their bedroom, but when that bedroom involves a pink four-poster bed, unicorn wallpaper, and a fully decked-out tea party you're always invited to, we gotta admit it's pretty soothing.

We shit on San Francisco a lot, but sometimes it's kind of cool having a place that's so here, queer, and used to it their sightseeing walks include historical penises.

Finding the platonic ideal of pleasant British friends at a music festival is like digging a Rolex out of a hundred-foot-tall mountain of shit.

Matching leather pants and Kangol are only acceptable if the rest of you looks like the guy who used to sell "hop" to Cosby.

Watching kids use their 20s to get back at their parents was a lot more fun when that meant fucking black guys and tattooing spiders across the bridge of their nose, not reenacting the time they got yanked up by one arm and told "Caleb! What did we talk about outside? We do NOT lie on the floor. Are you listening to me?"

Of all fruits to use as a marzipan g-string, this guy chose a pear?! THIS guy? He just ruined my entire worldview of gigantic black-man cock.

Well, at least we finally figured out who spilled the beans.

What the fuck are people talking about with the "models make real people feel inadequate" thing? If this makes you feel inadequate, then you probably are.

What kind of fucking asshole gives a tattoo to a six-year-old?

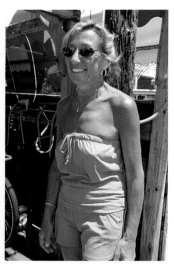

Oh this is perfect. Ricky LOVES music.

Beach aunts usually have a good enough track record with the ear-scorching gossip and the secretly putting more booze in your mom's margarita to make up for the fact that 90% of their body weight is skin cancer.

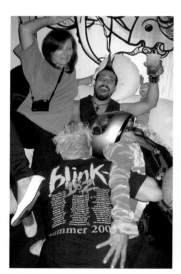

Always remember that getting a blowjob from a male friend only counts as gay if you make eye contact or stop scream-laughing.

For some reason this guy is awesome. Look at how focused he is! And what do you think is in his backpack? Bet it's full of hot dogs.

I bet you everywhere this guy goes he's like "I don't know how it happened!" and everyone's just like, "Oh Alonzo!"

While everybody's busy freaking out about Gore and Kunstler and Nostradamus's prognostications, we are listing ever closer to the future *MAD* predicted 30 years ago.

I think the theory that girls like watching guys fighting or racing cars or playing music because that's what their face looks like during sex is bogus, but I guess it never hurts to play it safe.

Have you ever noticed how often girls with big areolas tend to be completely out of their fucking minds?

That's fair, I can't even touch a joint any-more without my stoned mind conjuring an army of cops telling me my parents died. Meanwhile this guy is walking around so zenned out it's like the Sugar Crisp Bear had a kid with a sleepy baby.

Don't tell me New York is over when there are still hairdressing Sikh vogue artists *destroying* the Bowery on their way home from work. Please.

As Ally Sheedy proved nearly a quarter of a century ago, the easiest way to make guys lose their shit is to not have yours together.

Watching screamo and deviantART kids move into their preppy nautical phase must be what it felt like when Indians started wearing shit like top hats and suit jackets.

"*Trabajo? Ingles?* Great, I need three models for a college brochure. Just hop in the back."

Being really into dying young and the "27 club" is lame, but can you imagine if folks like John Lennon and Lester Bangs were still doddering around town, cutting witch-haus albums and writing Pitchfork columns from CMJ about how Wild Nothing is "missing the point"?

I know we're living in hybrid moments and cultural boundaries are permanently blurred and the Future and everything, but I still think you might have gotten "death rock" a little mixed up with "being a four-year-old girl."

If you're gonna take one part of an outfit and turn it all the way up to 11, why'd you have to turn up turn-ups? Those things SUCK. Were you not satisfied with getting home and just finding grit and cigarette butts in there? You wanted to move on to bigger and grosser things?

Oh good, the dry heaves I ordered just got here.

Look, you can either keep bitching about "the old New York" and how the city's basically become Disneyland for drunks, or you can start taking advantage and enjoy this shit while it lasts.

What, you're still into different genders? Yeah let us know how that works out for you, gramps.

Aw, that's sweet. I didn't know Make-A-Wish did ravers.

Whoa, what are those, Tomie dePaola juggler pants? Do those even exist? This kid is either the Temple Grandin of getting fag-bashed or the most effective jock-baiter since Neil Hamburger did his Red Hot Chili Peppers set at the University of Oklahoma.

Girls who know how to do olde-timey lingerie without making it some 1940s cosplay bullshit are basically boner Valkyries.

It only took them a decade and a half, but German teens have finally got 1992 down to a T.

Ever since that dude went off the cliff, Segway riders have been getting a little badass for their britches.

You know what? Fuck it—meeting's in four hours. I'll just do one more line, get a little breakfast, soldier through, and crash on the plane home. Easy.

Yeah, that'll show people who believe in that guy you don't believe in—dressing up like him but adding an element from that other guy you don't believe in who's his enemy. You're way too smart to get sucked into that shit.

Nothing shows contempt for your parents and everything their generation stands for like dressing in the exact same clothes and listening to the exact same bands they did to show contempt for their parents and everything their generation stood for.

This is what I figured the girl in all the Jawbreaker songs looks like.

Jesus Christ, God. You think making our grandma crawl across Frankfurt on her knees is maybe a little too harsh a punishment for remembering a blowjob she gave in the 30s? She's a thousand years old. What's the priest supposed to do after confession, give her a swirlie in the baptismal font?

Most ladies like it when their boyfriends are at least a little possessive, but making her wear a You suit goes way past class rings and letter jackets into some serious Phil Spector territory.

"Look, you got the Smashmouth CDs I sent, my niece taught you about the slang—what are you worried about? Everything's going to be fine. Now get in there and find out who their supplier is. Over."

Girls who think guys will talk to them if they dress up like video-game characters created by guys who are too scared to talk to girls is an even viciouser cycle than poverty.

Me wanting to have sex with you is exactly why your burka should be longer than that and why public stonings are so not funny.

One way to tell you're drinking in the right place is when closing time looks like the dictionary illustration for "deviant shit."

You know when you're having brunch at some trendy spot and light, nonintrusive house music is playing softly in the background? That's called brunch house. This guy makes that music.

I say we don't give the gays equal ANYTHING until we see some party equality up in here.

If you're a nerd who's having a hard time getting laid you can spend $20 for a bag of coke, $200 for a guitar, or eight years learning the Latin names for every part of the body.

How shitty is it that the cultures with the most assalicious men invariably have the harshest policies re: fireburn batty boy?

Dude, I know we said that with the right amount of confidence, you could pull off any look. But we meant like, "Victorian gentleman remix," or a weird hat or something. No amount of confidence is strong enough to make "imaginary gun at a SWAT raid" work.

Ha-ha, nice work German skinheads. You harassed South Asian immigrants so hard they finally assimilated to your culture. Your shitty, tacky, lawnmowing-dad culture.

A really great way to get to go to festivals for free is to volunteer to work for them. I mean sure, it means doing some crappy job for a couple of days, but what's the worst they could have you doing?

Man, I love art. But I wish it didn't have to be so over my head all the time. Real estate ad-style photos of bombed out houses on the Gaza Strip? If only I could decipher what themes this piece deals with!

I wonder whether their kid will rebel by having a sense of humor or going rivet.

No more beating around the bush with spanks and pinches and other juvenile bullshit. If you're going to call yourself an "ass man" in this day and age we want to see you bore your face right in there like a Herrenknecht Double-Shield Tunnel Excavator. Like, right now.

Turning your neighborhood into a coordinated network of bong-stations and liquor stashes and porno dumps sounds like a logistical nightmare but just think of all the wood head you'll earn as King of Your Suburb.

Not exactly prime babysitter material, but hearing this guy say "youngblood" would be like God cumming in your ears.

A lot of women's magazines like to stress the importance of subtlety and playing it cool, but if you're packing serious heat, let the ladies know that shit.

This would be a bit rich in America, but in a country where girls dye their skin orange and psychobillies have to use clothes hangers to prop up their two-foot-tall mohawks, mod *Akira* computer technician seems pretty reasonable.

If New York City is a woman, this is what she looked like around 1992.

If you thought the Dust Bowl and Eisenhower were a snooze, get ready for half a fucking century of "Did I ever tell you all about the time HR booted me in the neck?"

For some, college is a period of self-discovery and expanding your social and mental horizons while preparing for the rigors of working adult life. For others, it's a chance to get really interested in line drumming and explain to people how interested you are in line drumming.

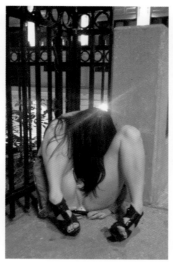

Man, it must suck getting married if you're a girl. You spend your entire life making scrapbooks of dream dresses and pretending pillowcases are veils at sleepovers and then you have to walk down the aisle with a 16-year-old who just borrowed his dad's suit for his first job interview.

I'm reluctant to say this since girls will think I'm suggesting that she's "asking for it" and guys will think I'm cockblocking, but maybe you should wait to get home to let your asshole read its texts.

The jacket is fitting, because over 15% of my thoughts right now involve AIDS.

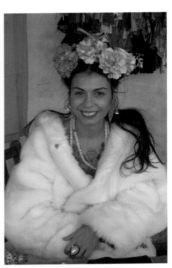

Quit telling high school students to march to the beat of their own drummer. All it does is get a half-full milk carton chucked at their head while the entire lunchroom stands to laugh at the resulting splooch. If you want to give the kids some real guidance, tell them to drum to the beat of their own drummer (which is them). That's the kind of counseling that can turn your average Angus into a sweat-caked teenage pussyhound.

The only thing we see wrong is the chest tattoo, but even it ties into the overall Frida Kahlo-Miranda-goes-to-Monaco package, so we're going to resume making our plans dump all our current friends and find a place that sells spats and nosegays.

I know people say don't wear your heart on your sleeve but fuck those nerds. If you heart a girl, wear that shit all over your sleeve. Hell, put it on the front of your shirt then park yourself in front of her favorite bar like a human "Eh? Eh?"

See? Shirts work. Shirts bring people together, shirts keep people together, and shirts let people know which people are together and will stay together until they are both stretched out and yellowing under the armpits. I bet God's shirt is a picture of these guys in their shirts.

Hey, it's Pvt. Troy "Eagle Eyes" Larson. I had you! Complete with Cybershock® Power Gauntlet and Tactical Antenna Pack. So now you're a person, eh? Hope Afghanistan's going better than Hunter Eden's yard. We lost a lot of good men on that lawn.

Is there anything grosser than little brothers? They're always in your room and messing with your tampons and bringing up the time you pissed yourself in front of the guy you like, and whenever their brood of friends spends the night you know you're going to find at least one pair of your underwear wadded up behind a couch cushion. Just looking at this picture makes me want to check the bathroom for cameras.

Holy shit do we love short, brassy Jewish broads. Who cares if they make irritating girl-friends? They look good in punk, they've got that weird honking voice that sounds like a goose shit-talking the people it works with, and they single-handedly constitute the best babysitters, gossips, female weed smokers, nacho companions, and accidental blackout lays we've ever known.

Instead of just watching on TV and waiting for some asshole in a suicide belt to take advantage of all the crowds in Egypt, why don't we circulate a couple of our own guys and see if maybe partying will help?

There, we cropped out the short hair so you can quit debating whether or not she likes guys and start trying to deal with the fact that the only way you're going to get her into your bedroom is on the off-chance she grew up with a Bud Bundy fetish.

You can keep your Suicide Girl with the clit piercings and chest tattoo who can only get off while pegging you in an inverted sex swing using her ankles to hold a Hitachi Magic Wand against her taint ring. Give me a lady with simple, classic tastes any day of the week.

When Ben Weasel sang "*You don't have the balls to be a QUEEEEEEEEER*" he did-n't know it would resonate so heavily in the Balkans, but it did and now militant homo drag punks is our second-favorite Romanian export after snowmobiles.

You ever get so fucking drunk that your hair takes a shit?

Once upon a time, poor people had their own delicious, high-potency malt beverage that tasted like fruit. Then frat boys caught on, one drank too much and died, and now it's banned. Nice work, dead white guys. Slavery, the displacement of the American Indian, and now this.

We asked if he thought that girly fruit thing made him look like a pussy and he said, "Yeah, but he ordered me, so what are you going to do?"

This reminds me of that part in the movie *The Hustler* where I got so bored I changed the channel and watched Judge Judy instead.

Remember before yellow cars when you had to talk to a guy to figure out he was an asshole?

Take a week off from work and when your boss calls to ask where you are, you tell him, "I'm celebrating the midget."

I was at the grocery store a few months back buying baby carrots and they were playing Bob Seger's "I Love to Watch Her Strut" on the radio. Now whenever I eat baby carrots I think of Bob in an old folks' home eye-raping the staff's assholes.

What is it about chicks who've had a stroke that makes them so incredibly hot? If you've ever jerked off to Picasso's *Guernica* you already know the answer to this.

Girls who ride horses give us the same uneasy feeling as girls who leave their vibrator out on the dresser, but can you name another outfit where each individual item is better than nude?

Fuck Steve Jobs! This son of a bitch just invented the Spermtini!

Having a huge plate of candy at a party is the opposite of "wilding out." We call it "childing out," and if you try that shit at our party prepare to have that platter spanked out of your hands so hard there will be a full minute of stunned silence before you start crying.

We all secretly wished we had leukemia when we were nine but carrying that shit into adulthood and thinking we're all just going to be cool with it is like booking a Toto Tour to Uganda.

If two chicks making out in front of a nightclub gives you an erection, you probably don't have the internet. The only public girl-on-girl action that gets me hard these days involves topless Japanese girls, three to four quarts of milk, and a whole lot of them barfing on each other.

Every time some turd on Twitter goes off about how it's 75 degrees and sunny in LA mid-January, I make a mental note to thank the five-foot piles of frozen New York car exhaust for keeping shit like this at bay.

Oh really? You went to Gathering of the Juggalos and took a picture of a kid in clown makeup smoking angel dust? As the French say *le yawn*. Give us a call when you start shooting big game, like the mating habits of the Western Ontario Crested Junglist.

I'm sorry, but standing in front of a bunch of candies dressed like a bunch of candy doesn't change the fact that we could smell the rancid piles of cat-piss-soaked laundry and unwashed menstrual cups haloing your bunk bed through a Yankee Candle outlet store.

Girls who try to do 1940s Lana Turner shit with their hair usually end up looking like the playbill for Murder Mystery Night at the Ft. Lauderdale Dinner Theatre, but letting a wink of it peek out from the top of a motorcycle jacket while everyone else in the city is still a frumpy, sexless Michelin mummy is like combining the first blossoms of spring with that part in *The Wall* where the flowers fuck.

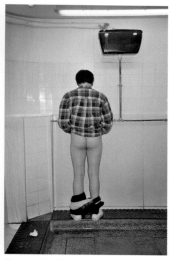

Whoa, I know we all agreed 40 is the new 30, but who made 67 the new 9?

If you're ever skeptical of the triumph of machine over man, check out what happens when a real woman tries to keep up with the internet: crying in an impractical $500 outfit as the man you love jerks off onto someone's asshole in the distance and a chihuahua edges toward your pussy.

Moments like these make me wonder if hipsters really are pampered upper-middle-class wimps or just super-avant-garde performance artists expressing themselves through the medium of having the rest of the world hate them?

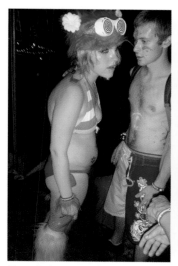

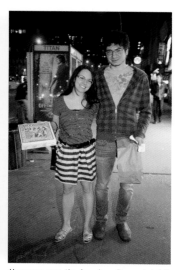

It's a sobering moment for most of Thailand's gap-year rave princesses when she realizes the sweetest thing she could do for her parents is spend their money on a half-decent dress to kill herself in.

This guy is waiting for the tsunami of pussy to come crashing down on top of him and sweep him out into a sea of lots of other fantastical bullshit that will never happen.

Have you seen the American Dream lately? Well, you're looking at her right here. A couple of asexual nerds, hot pizza, a bag full of Proactiv, and a whole season of *Off the Map* to look forward to.

Wait a second, does ice skating secretly rule? I get that it's just one step away from both professional dance and beauty pagents, but homos are usually our canaries in the party mine and this picture looks like more fun than Bolan and Bowie at Studio 54 circa tag-teaming Mick Jagger.

Being a regular means more than just showing up once or twice a week and fading into the woodwork. You've got to dedicate yourself full-time to sync'ing your rhythms and absorbing so much of the spirit of the place into your personality that you actually become the bar.

Well aren't we a scrumptious little dawber? Aren't we a dinky little doozer, dancing around the kitchen in our wee black undies? Aren't we a diddly widdle doodlebee? Aren't we a cheeky widdle monkeybug, pat-pat patacaking some little patties to put in our wum-wum? God I am hard right now.

This guy's like a toned-down version of the last DO, where his dinky-dandling days are over and now he just gets up on the bar every so often when the mood is right and does a little Pee-wee dance that brings a tear of fond remembrance to all the old timers' eyes.

The Indians called corn "maize." Probably because of how "amaizing" it feels when you stick it up your cunt.

Sexual mores have come a long way in the last 100 years, but we're not at "Honk honk how are you?" quite yet. There may be some emancipated lesbian communes in Oregon where this kind of salutation floats the boat, but right now you're just providing another textbook illustration of why your friends call you "Liability Andy."

"You Americans think is funny when Mikhail is saying 'make party,' but if you ever see him actually make a party in festival car park, airport bathroom, on metro, or even just by self in Moscow apartment alone, then you would understand is not so funny."

What the hell is this? The bodystocking simultaneously rubbing against the lycra shirt and velveteen housepants wasn't gagging enough eyeballs, so you ripped the drawstring off a theater curtain to add a kinetic flourish? You look like something my dad is angry at my mom for buying at the arts fair.

Remember that first swell of confidence when you were 13 and started to be friends with girls and get into music and were like, "Fuck what people think, fuck what TV thinks, there's no such thing as 'trouble,' reality is whatever I choose to make of it." You have no idea how close you were to a daily holocaust of bullying.

Isn't it weird the same rich people who won't let you say "blowjob" on TV are cool with their tween daughters regularly straddling a giant surrogate dick? What's with that? We don't let boys hang out with giant pairs of tits. We definitely don't let boys spend all afternoon huffing their tits' ass.

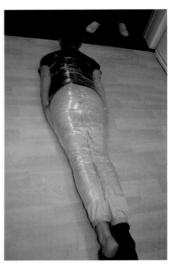

Sorry ladies, I know you like talking about "buns" because it makes you feel like a saucy, oversexed aunt, but we're taking back the butt. We just appreciate it more. It took my girl-friend 15 years of fucking to realize that guys' assholes tighten when they come, meanwhile I wrote my dissertation on Perineal Tremoring in the Urogential Triangle from memory. The things gays could tell you about the ass would be indistinguishable from magic.

Ditto being turned on by squnching up your ass and tits in weird materials. Remember in *Kids in the Hall* when Scott was the mom and said, "I do everything short of greeting you at the door in Saran Wrap"? It's some-thing no woman voluntarily does outside a "Happy Birthday, I guess this is what makes you horny" sense.

Why is *Cosmo* still telling their readers they have to buy blowjob lessons and body oil and anal beads to "please their man" when all we really want are the things they've already got, like mishapen areolas and those weird bruises right at the crease of their ass.

When Australian girls saw videos of No Pants Day in New York, they said, "Bluff called." Now everyone is walking around in permanent morning-after-sex mode with wads of cash and spare sunglasses shoved down the back of their underwear, and the only thing keeping a forest of boners down are the onipresent flip-flops.

On second thought, maybe it's smart to limit the No Pants to once a year. We don't need to be trying to get shit done with asses everywhere bouncing all over the place and slapping us in our slobbering faces like a living R. Crumb drawing. Just an occasional taste is fine.

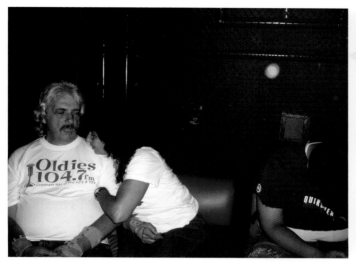

"And I said, 'Look, I don't know where you're coming from, but I've been installing TU47s since you were in grade school and if you don't start with the intake shaft the second you turn that on you're going to have a jammed blade.' But no, we try it Mike's way and guess what? Jammed blade. So now I gotta uncouple the whole back assemblage and I got the guy who runs the place barking up my ass 'cause he thought we were going to be out of there by 3 and on top of that Mike switches back to that station that's always got 'Miss You' going and it's like, man, I don't want to listen to fag-era Stones while I got my hand stuck down an eight-inch section of tubing, especially with my wrist still gummed up from that boat wreck at your sister's place. But at least I got the satellite radio fixed on the van so I'm in control when w..."

The scary part is I don't think this guy is even whipped. I think he's your standard, no-maintenance sofa dad who went with the flow a little too hard and is just now realizing that "Wear that shirt I like" morphed into some sort of mentally ill "Donny & Marie Live in Miami" situation years ago.

What's wrong with this? Dude's two generations removed from the folks who stole the Indians' land and he can't wear just a little of their ceremonial garb to show what a free spirit he is? What a gay crock of PC bullshit. Next you'll say my German cousins shouldn't dress up as Anne and Otto Frank for Roskilde this year.

OK, how about if we spend a lot more money on it and take it into cornball heterosexual fantasyland so it's like a Trail of Tears version of *Mandingo*? That should be better, right?

Oh, now that's just great, Ira. I spend the last two DON'Ts trying to make this big point on behalf of your people and you're on Etsy selling, what are these, Ugg moccasins? Really? Uggasins?! Forget it, buddy. You're on your own.

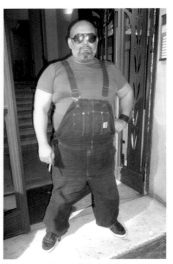

When black people get stoned there's nothing they can do to hide it. That's why Odd Future wear sunglasses and Stevie Wonder went "blind." White kids have got it a little easier, but if you're a sunburned Filipino it's always 4:20 somewhere.

If you haven't played the Latvian porn version of *Super Mario*, you won't know about Lubeigi, but when he gets the blue turtle you know he's about to cum pretty fast from behind!

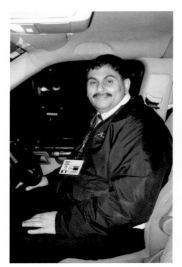

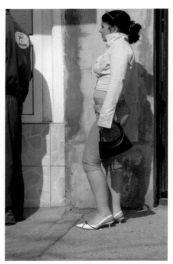

This aging coke fiend we used to be friends with once had a heart attack in this awful nightclub and was legally dead for three minutes. When he woke up he was super calm. He said dying was a wonderful feeling, he said it was just like being taken home.

Let's play a little game called "What do you think she's waiting in line for?" I'm gonna go ahead and say pie.

This is how it starts. Two young nerds meet and fall in love, then they begin breeding a race of übernerds that will plague our earth with soul-crushing comic-cons and time-slaughtering Facebooks and beer so ironic it will make your teeth bleed… Sounds good.

We understand Mediterranean chest hair can be a literal handful, and we're not about to get on your case for shaving it all off instead of having Gene Shalit forever peeking out of your collar. But you've got to go whole hog one way or the other. Looking at you right now is making me itch in places I didn't realize had skin.

Finding a girl who thinks Benny Hill is funny is rare enough, but finding two best friends who are not only unabashed in their love for the Sultan of Sax but came up with their own "reaching for the popcorn" gag in His honor is like winning the human-being lottery.

Remember when Sarah Silverman said, "When life gives you AIDS, make lemon-AIDS?" Well, leave it to the Germans to take that shit literally.

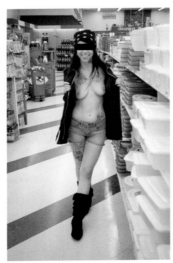

It's cute to force your religious beliefs on your pet, but just remember what happened to another wise guy who tried to do that by the name of Dr. Moreau. He wound up getting his balls ripped off by a pack of raging manimals, and I don't even think he was Jewish.

The next time you buy Tupperware, remember that there is a 99.9% chance that somebody got fucked on it.

"Chunky" heels are cheating, but this is more of a Japanese *geta* thing which is arguably even worse for your ankles, so our dicks will give it a pass.

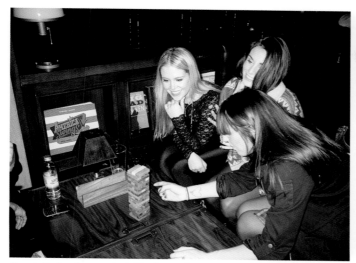

Three hot babes, Jenga, and a bottle of water. This looks like one of those legendary Mötley Crüe parties I've read about.

Ha ha ha! That's really funny, guys! How about next Halloween you paint your faces black, wear Afro wigs, and carry around a banjo since making fun of downtrodden minority groups is so hilarious.

In olden times ships would have a long rope that hung down into the water and the passengers and crew would all use this rope as a sort of community toilet paper. Whoops! I think you just learned something.

"Welcome, my weight-watching children of the night, to my Warehouse of Horrors and Unbeatable Savings, where you can experience the gut-shredding terror of Slim Fast Nightmare Milk, specially brewed inside an evil witch hat and stirred by 666 giant demon boners on Halloween night."

Maybe you should forget about the lap dance and start thinking about a LAP BAND! In all seriousness though, take care of yourself. Obesity is a killer. RIP Nate Dogg.

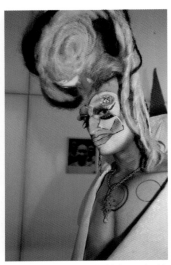

Though the late 90s nearly killed it with the boot-cut jeans and JNCOs, girls have finally reawakened to the full power of sock culture. It started with leg warmers as a joke, then progressed to those gym socks with the stripes, then dark socks with shorts, then dark socks with shorts with heels, and now men are being treated daily to exotic boner fruit like horse socks in busted loafers that are physically impossible not to picture you naked in. What a time to be alive.

"I don't know, I still don't think you should have taken the drink from that guy. He keeps looking over at you an—there! He just did it again. Did you see that, Angie? Angie? Why are you laughing? Hellooooo? *Annnnngiiiie? Whaaaaart's soooooo fuuuu- uuuuuuuunnnnnneeeeeee?*"

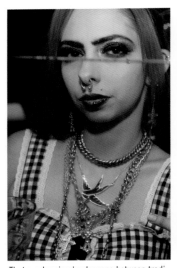

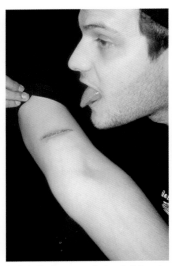

That overlapping border zone between traditional goth girls who're still pissed at Valor for stealing Christian Death and East LA cholitas who razor stripes into their eyebrows and have 30 terrifying brothers is like the DMZ of sexual minefields.

Look, ladies love guys who love to lick gash, and the only way they're going to know this means you is if they see you out there, licking whatever gash you can find wherever and whenever possible. I don't understand what it is about this you're not getting.

You're pretty black when your weave also has a weave.

Once I was at a *Vagina Monologues* cast party and I blacked out. The next morning I woke up in a tub of ice with my balls missing and a letter that said, "Dear John, Fuck you. Sincerely, Your Balls."

If you're ever feeling weird about wolfing down a bunch of antidepressants every morning to make it through your day, just take a glance at this picture and be glad you weren't crazy 100 years ago when "psychiatric medicine" was basically a frat house run by the Three Stooges.

Was Darill not an effective warning? Are there still really jerkin'd jerks who think a carefully braided ponytail and heaping bowl of motherlove will sweep the girls off their feet and into their old-fashioned arms? Knowing this guy's out there makes me feel the same way Christians do about unsaved cannibals on Borneo.

Can we please stop trying to reinvent the skate wheel and give it a rest with all the long boards and snake-boards and skate-shoes and wiggle-wheels or whatever they're called? Even my mom sees these and thinks "That fag can't skate."

This is like that scene in *Bill & Ted's Excellent Adventure* when they kidnap Marie Antoinette, Richard Simmons, Sha Na Na, and a raccoon and they get sucked down into a black hole and the g-forces are so powerful it smashes them into one nasty attitude.

Extreme-metal Cruella de Vil seems like a major no-doy until you realize that even if you had thought of it first, it would still take you about two full bags' worth of confidence to pull it off.

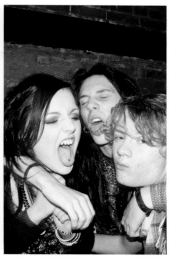

It's easy to see a bunch of people at a steampunk meetup at your local bar and say, "Ha ha ha, look at those ridiculous, self-absorbed man-children," but if you ever had a phase in middle school where you were really into anime I think it's healthy to take a deep look into these mono-goggled faces and say to yourself, "Wow, there but for the grace of God, taste, dignity, getting laid, work, drugs, friends who'll call me out on stupid shit, self-awareness, a sense of humor, and not living at my parents' house go I."

Your older sister's friends seem like the coolest people in the world until they take you out for your 14th birthday and you suddenly realize that sitting at home on Facebook is way more fun than doing Jäger bombs in Mike's basement and pretending to be wasted in every photo.

Rarely can one shirt-and-pant-and-face-and-hairline ensemble capture the essence of staying up till 8 AM doing horrible cocaine and arguing about guitarists in a first-floor LA apartment with no natural lighting, but wow does this one and holy shit did that night suck.

I guess you've got to do something to compensate for that Cro-Magnon brow, but reading Zola at a music festival is the kind of misguided teen intellectualism that only appeals to girls who like to cut their wrists with razors and packs of guys who like to punch your head with fists.

A friend of mine just moved back East from Southern California because he was worried all the sun and outdoor weather might be giving him skin cancer, but personally I'd be a lot more worried about all the people and drugs giving you brain dumbcer.

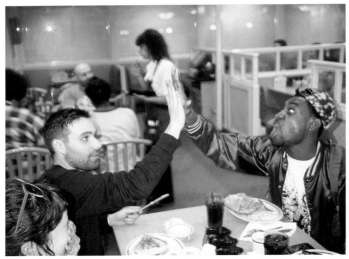

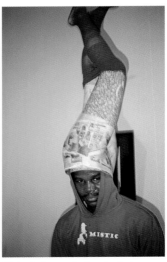

Here's to the 5 AM smashed-out-of-your-mind breakfast and making best friends with total strangers cause they agreed with you that eggs over easy is better than sunny-side up.

It's fun to be a pretentious twat when you're in college and come up with a bunch of high-concept bullshit that dialectically reorders the nexus of gender and class, but more often than not the best artwork comes from the simplest places. Like having legs on your mind.

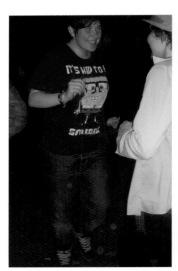

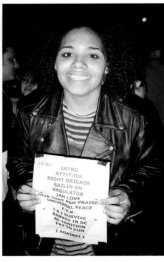

Fuck, do you remember the first time you got really wasted and danced with the guy (or girl) you secretly liked? Your brain was like, "If heaven's like this, then that's the place for me."

Guess what? Santa finally heard your prayers and brought you a little sister and she's half-black and she's into Bad Brains. Timing could be a little better, sure, but if I were you I'd quit the griping and get some quality time in before she makes it to *Quickness*.

While you have to dump him the second you turn 30 or have anything that can be described as a "profession," dating a lazy goofball version of yourself is a pretty adorable option for attractive beta gals in their 20s.

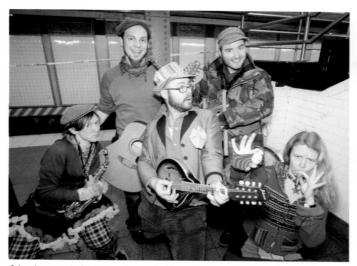

Crime is up on the New York subways. And I'm not talking about cool crime, like assault or robbery or murder. I'm talking about sound crime as perpetrated by packs of olde-tyme, kazoo-wielding retards who steal the last shred of tranquility from your mind and grind it against a washboard to the tune of "Goober Peas."

Momentarily sidestepping the crotch shorts, public writing project, and twin loneliness mascots, nothing says "I know less than three black people" more than a Coors Light hat that was pre-tattered at the time of purchase.

Ah yes, the cute girl playing the ironic angry trailer-park housewife. Very funny. This must be a still from someone's *SNL* audition tape. Someone who will soon be making more money exchanging bawdy repartee with David Spade than I have made in my entire life.

When you dine at Ye Olde Hooters prepare to be transported back to an ancient time when men were men and Mountain Dew was served by a comely wench with Mike Tyson tattoos all over her tits.

Billiards is the ultimate game of precision and skill. It takes expert hand/eye coordination and the patience of a Zen master. A thinking man's game. Especially men who enjoy thinking about how they're never going to get laid.

Taking "Careless Whispers" to the food courts and classrooms of Southern California is a nice gesture, but it's preaching to the converted. If you want to see people making a real difference take a look at the true sax missionaries out in the field, bringing blistering riffs and sultry squealing bleats to those who need to hear it most.

Can you believe all the neocon frat boys still gloating over the end of the Cold War like Reagan did it or that the resulting liberalization of the markets didn't leave Eastern Europe awash in corruption and instability? Or that it doesn't hurt the shit out of this guy's feelings?

Here's another question: If Serbia lost the war how come our TV personalities are all dowdy spinsters in Talbots blazers while theirs look like someone fed the phrase "literally more woman than you can handle" into the *Weird Science* computer?

Wacky piping always seems like a jacket dealbreaker, but sometimes you just have to bite the bullet and let the jacket take your personality where it will. Even to the set of *Boner Academy IV* starring Bobcat Goldthwaite.

Man, remember crushing out on some weird, unexpected friend of yours and how fucking wrecked you felt the second you realized it was on? This girl must be like the Rogue from X-Men of that feeling because her touch looks like it is literally killing him.

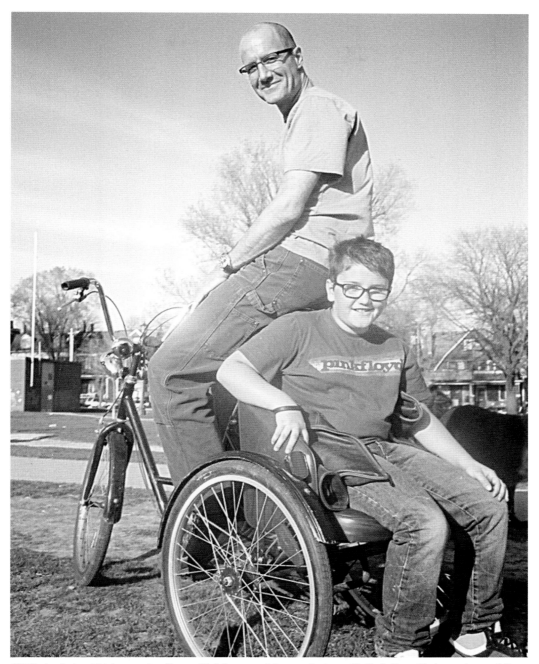

"Hi! I'm Lambert and this is my nephew Magnus. His father was a fisherman who drowned in the Baltic, so I try to spend as much time with him as possible. This is a bike we built together." Did you expect something scathing? Well, guess what, fuck YOU. YOU are the DON'T. These motherfuckers are so great it should make you reconsider your entire life. What are you even doing reading this? Go find a local youth organization and mentor the shit out of an emotionally neglected kid who needs you.